THE

IN LAS VEGAS

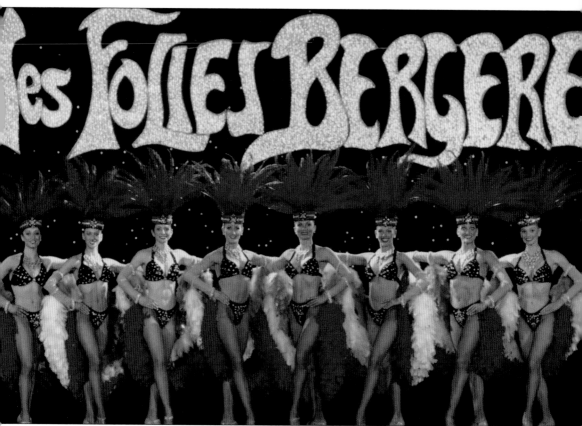

In this photograph, a line of costumed showgirls pose with the iconic "les Folies Bergere" lighted set piece. This sign was illuminated with hundreds of bulbs and was first used onstage in the 1975 edition of the show. (Courtesy of UNLV Libraries Special Collections.)

THE

Folies Bergere!

IN LAS VEGAS

Karan Feder

Foreword by Jerry Jackson

ARCADIA
PUBLISHING

Published by Arcadia Publishing
Charleston, South Carolina

Printed in the United States of America

Library of Congress Control Number: 2017955633

For all general information, please contact Arcadia Publishing:
Telephone 843-853-2070
Fax 843-853-0044
E-mail sales@arcadiapublishing.com
For customer service and orders:
Toll-Free 1-888-313-2665

Visit us on the Internet at www.arcadiapublishing.com

To Mr. Feder

CONTENTS

FOREWORD

Celebrated as one of the biggest attractions in Paris, the *Folies Bergere* excelled at transporting audiences to a world of fantasy and glamour. The show's legacy in Las Vegas is worthy of comparison, and I am proud to have been a part of it.

My association with the *Folies Bergere* gave me the opportunity to pursue my passion for art, dance, and music. I was privileged to collaborate with brilliant designers, technicians, musicians, and the incredible Hotel Tropicana producers and entertainment department personnel who brought everything to fruition.

Although the *Folies Bergere* is famous for elaborate sets and costumes, it was the award-winning casts and the dedicated crew members who created magic on the stage night after night. We strived to maintain a high standard and relied on audience response and reviews. I am especially proud of one such review from 1991, written by Charles Marowitz for *New York Magazine*: "*Folies Bergere* . . . staged and choreographed by Jerry Jackson . . . moves with the precision of a set of tumbling dominos and displays the kind of design-flair which, were it to be found in a Broadway musical, would be the talk of the town. . . . the gusto, fluidity, and choreographic invention that sustains *Folies Bergere* is a real achievement wherever one might encounter it. . . . [*Folies Bergere*] has the fanciest hoofers and the most esthetically-pleasing showgirls and is a marvel of synchronized stage-effects."

A huge debt of gratitude is owed to Karan Feder for diligently researching, documenting, and preserving this legacy. Without the tireless efforts of her and her staff, the *Folies Bergere* would exist only in memories and fragmented references.

—Jerry Jackson

Jerry Jackson's creative collaboration with the *Folies Bergere* commenced in 1966 and extended through the show's closing curtain in 2009. From 1975 forward, Jackson was the Las Vegas production's architect and patriarch. His indispensable contributions encompass a broad range of disciplines including creative director, choreographer, musical composer, lyricist, and costume designer.

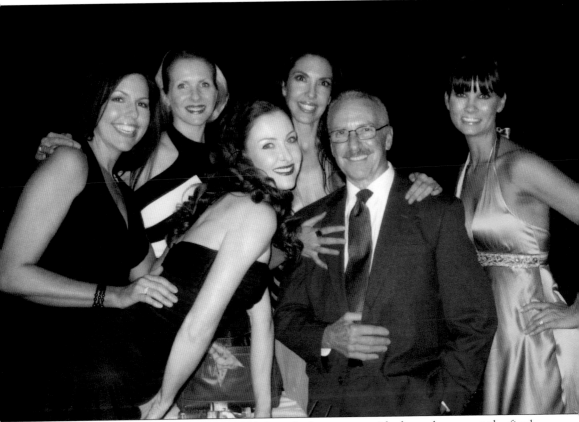

In this photograph dated March 28, 2009, Jerry Jackson poses with show alumnae at the final performance of the *Folies Bergere*. Vicki Pettersson (left) and Debbie Freedman Kaufman (right) flank Jackson while Trish Willis-Randall, Rosemarie Brown Caspary, and Kristine Perchetti are pictured from left to right behind them. (Courtesy of Jerry Jackson.)

ACKNOWLEDGMENTS

This book would not have been conceived but for the generous donation made by the New Tropicana Las Vegas to the Nevada State Museum, Las Vegas, in 2015. My champion, entertainment manager Eric Puhl, facilitated their gift of over 8,000 costume pieces, and for this, the museum and I are forever grateful.

Many thanks to my Arcadia Publishing editors, Alyssa Godwin and Liz Gurley, and to publishing manager Michael Kinsella for embracing my fascination with the legacy of Las Vegas's *Folies Bergere* and for having faith in my ambitious vision for the project.

I am thankful that Dennis McBride, director at the Nevada State Museum, Las Vegas, has trusted in my grandiose and outside-the-museum-box aspirations with absolute enthusiasm. The professional staff at the Nevada State Museum, Las Vegas, has been both patient and understanding while my department endeavors to process the ample donation into the permanent collection. I am indebted to the museum's costume and textile collection volunteers who consistently and excitedly dedicate their expertise in service of the collection: Karen Bauer, Eduardo Jimenez, Jean Panaccione, David Porcello, Angela Santangelo, Hilda Scheiner, Jana Schultz, and Annie Stephens.

The many prominent professional photographers at the Las Vegas News Bureau, past and present, who have passionately documented the boundless splendor of Las Vegas, are my heroes. In my quest to preserve the *Folies Bergere* costume collection, the Las Vegas News Bureau's Lisa Jacob, Kelli Luchs, and Ginny Poehling have served as invaluable partners, and I am deeply thankful for their continued support.

At the University of Nevada, Las Vegas, the library staff, Delores Brownlee, Karla Irwin, and Su Kim Chung, provided an abundance of expert assistance relevant to the university's Jerry Jackson Papers. The opportunity to directly correspond with Jerry Jackson during my research has been both indispensable and inspiring. I am delighted when Jackson warmly returns my telephone calls and replies to my letters filled with peculiar yet consequential queries.

And finally, I thank the *Folies Bergere* family of alumni who guided me on this journey and, in so doing, made me feel like one of their own.

INTRODUCTION

Las Vegas's first gambling halls of the late 1940s introduced the chorus girl to the desert. The early chorus girls were dancers and sometime singers costumed in close-fitting and revealing outfits. Although appealing and captivating, nudity, height, and glamour were not yet a part of this entertainment equation. The phenomenon known as the Las Vegas showgirl was imported directly from the French music halls, where sophisticated, stylized French titillation was offered nightly.

As the mid-20th-century Las Vegas Strip developed, so did the competition between rival properties, with each hotel advertising "the most beautiful girls in the world" and boasting the grandest, most lavish, and expensive stage extravaganza produced to date. The objective was to lure folks in the door with an irresistible show and then send them directly onto the casino floor. In 1957, the Hotel Tropicana, nicknamed the "Tiffany of the Strip," was the most expensive and swanky resort ever seen in Las Vegas.

The showgirl is a symbol of ideal feminine beauty and a cultural archetype. She embodies that which women admire and men yearn for. Her physical silhouette is continually adjusted to suit the fashion of the era. Today's modern showgirls are bona fide athletes and formally trained dancers. The iconic Las Vegas showgirl is a product of 19th-century Parisian cabaret theater. The traditional French musical revue show adheres to a timeless formula that includes elaborate and visually resplendent numbers featuring male and female dancers, singers, leggy showgirls, and amazing acrobats. Incorporated between the extravagant song and dance production numbers are curious and highly polished specialty acts and novelty numbers featuring vaudevillians, comedians, and circus performers. Although exquisite showgirls appear on stages around the globe, Las Vegas claims ownership of the icon, and the showgirl serves as one of the quintessential symbols of the city.

Las Vegas Sun newspaperman Hank Greenspun described the debut of the *Folies Bergere*: "It's the old French theory of 'girls, girls, girls.' They come at you from all sides in the most dazzling of costumes and shapes. And not just a display of feminine nudity, but beautiful, talented dancers whose facial expressions and body movements are continental theatre." During the 1960s and continuing throughout the 1980s, this distinctive art form developed into an essential element of the Las Vegas identity. Tourists and locals crowded onto the Las Vegas Strip for the opportunity to experience the extravagance and enchantment of cabaret theater.

The stage wear featured in this entertainment genre is known as cabaret costume. The style is most notably characterized by a focus on the veiling and unveiling of the female form. Typical rules of placement, coverage, form, and function are ignored, thus obscuring the lines between the seen and unseen. Feathers, furs, fishnet stockings, fans, gloves, rhinestones, and sequins are the accoutrements used to define the allure and excess of this art form. Although steeped in tradition, the art form does indeed reflect the desires, whims, and values of contemporary culture. As a rule, the costumes of the music hall embrace and celebrate, at once, the elegant, absurd, and erotic.

There are few opportunities to study the costumes of this unique genre or to interpret the art form's relationship to American culture. Too often, retired cabaret stage costumes are sold to other productions, the embellished sections are removed and recycled into new pieces, costumes are destroyed to protect copyright infringement, or they are simply thrown out to make room for the new. This publication results from the once-in-a-lifetime acquisition of the entire existing costume stock of the American edition of *Folies Bergere* as staged at the Hotel Tropicana in Las Vegas, Nevada, from 1959 through 2009.

The costume and textile collection at the Nevada State Museum, Las Vegas, was the recipient of the vast archive donated by the New Tropicana Las Vegas in early 2015. Materials received include sheet music, stage props, costume and set renderings, wardrobe department materials, ephemera, and stage costumes. As a consequence of this significant acquisition, the Nevada State Museum, Las Vegas, is proud to preserve and conserve one of the largest and most comprehensive museum collections of cabaret costume in the world. With close to 8,000 objects in the *Folies Bergere* archive and spanning a 50-year period, there is plenty to interpret, study, and treasure.

As is the case with most museum donations, the *Folies Bergere* collection arrived at the museum altogether uncatalogued, un-inventoried, and undeniably unorganized. The sky-high piles of boxes and bags filled with varied and fascinating material posed a considerable cataloging challenge. Several of the immediate questions from the curator (who is also the author) were, "What year, which scene, and who wore this?" It was speculated that the shortest route to comprehension would involve the study of existing photographs documenting the Las Vegas stage show. Three crucial archives were discovered: Las Vegas News Bureau; University of Nevada, Las Vegas Libraries Special Collections; and the delightful scrapbooks of *Folies Bergere* alumni. These collections offered access to professional photographs made during live performances, behind-the-scenes amateur photographs, business papers from the production, promotional materials produced by the Hotel Tropicana, and other revealing ephemera. *The Folies Bergere in Las Vegas* compiles and interprets a large portion of this research.

Debuting at the Hotel Tropicana on Christmas Eve in 1959, at a reported cost of $1 million, the *Folies Bergere* stage show featured a cast of "eighty stars" and promised a stylized evening of sensual entertainment. Imported directly from Paris, the iconic French production, famed for its elegant and chic legacy, was a mainstay for nearly half a century. A 1959 *Las Vegas Sun* newspaper article portends the significant role that the *Folies Bergere* would play in the city's history: "From beginning to end this is the most dazzling entertainment which any city has been privileged to see. It's saucy, piquant and racy in the splendidly provocative French way. Las Vegas, the entertainment capital of the world, is now no idle boast."

Forty-nine years and three months later, the curtain was abruptly lowered on the nation's longest running show. The Great Recession had taken a bite out of Las Vegas, and although the iconic musical revue was synonymous with the Hotel Tropicana, the resort's financial situation forced a premature closing just shy of the production's golden anniversary. A local magazine describes the show's imminent final curtain: "Say what you will about its age, and while it hasn't quite reached its 50 years, it's still golden in our opinion." On the evening of March 28, 2009, in the aftermath of tens of thousands of performances, the current and former cast and crew gathered together in the Tiffany Theatre to embrace and celebrate the final closing night of the *Folies Bergere* in Las Vegas.

One

TERRIFIQUE! MAGNIFIQUE! TRÈS UNIQUE!
THE PARISIAN EXTRAVAGANZA COMES TO AMERICA

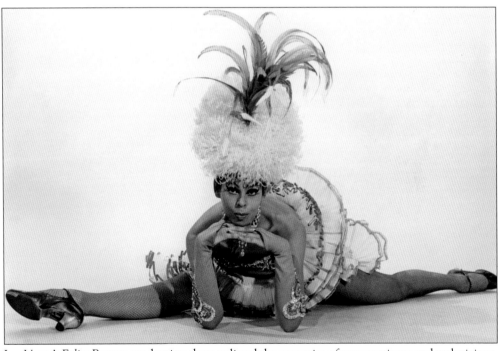

Las Vegas's *Folies Bergere* production show enlisted the expertise of many artisans and technicians. The creative entities, such as producer, director, set designer, costume designer, lighting designer, orchestrator, and choreographer, were those individuals responsible for conceiving the stage show. The performers, in concert with electricians, stagehands, musicians, and wardrobe assistants, were responsible for giving birth to the show. This photograph was taken in the mid-1960s. (Photograph by Rob Gubbins.)

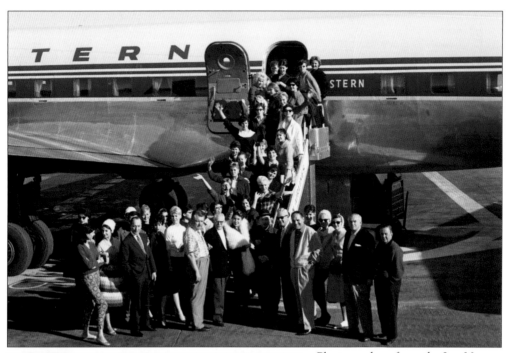

Photographers from the Las Vegas News Bureau were on hand to document the arrival of the *Folies Bergere* cast and crew traveling from Paris to the Las Vegas McCarran Airport. Just a few weeks shy of opening night, this image was taken on November 29, 1959. (Courtesy of Joe Buck/Las Vegas News Bureau.)

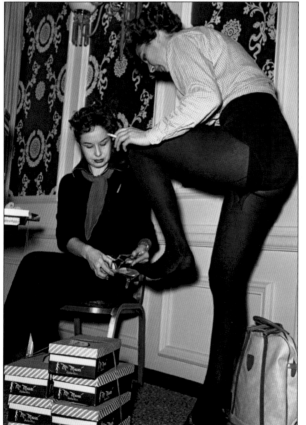

Cast in the debut edition of the *Folies Bergere*, Virginia James's employment contract stipulated that she perform in, at a minimum, 15 shows per week for which she earned $108. In this photograph from 1959, a showgirl is fitted for shoes to use onstage. (Courtesy of Joe Buck/Jerry Abbott/Las Vegas News Bureau.)

The job had more perceived glamour than material reward, but nearly without fail, show alumni remember their tenure with the show as the best time of their lives. The showgirls in this candid photograph relax in their backstage dressing room until it is time to prepare for the next performance. (Courtesy of Lisa Malouf Medford.)

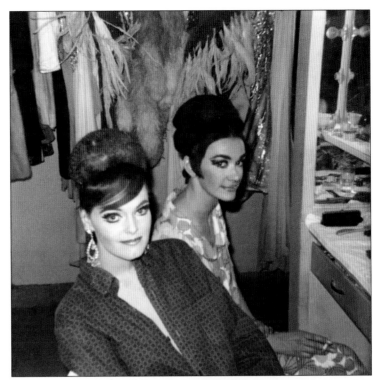

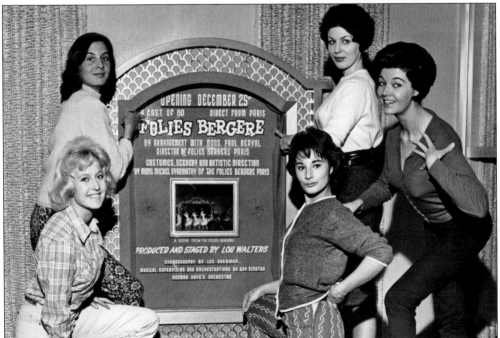

The *Folies Bergere* was one of the large-scale, costume-spectacular, Parisian imports on the Las Vegas Strip during the mid-20th century. This photograph from 1959 features women from the original cast posing with a promotional sign announcing the opening performance of the Hotel Tropicana's new musical revue. (Courtesy of Nevada State Museum, Las Vegas.)

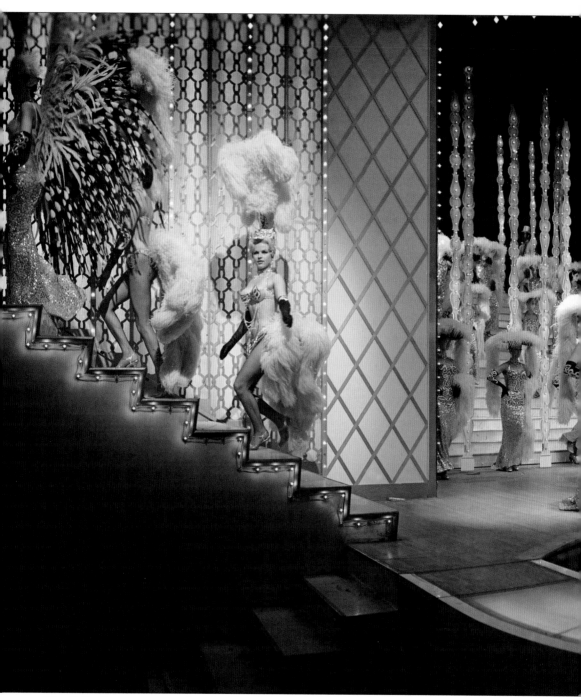

The *Folies Bergere* was staged at the Hotel Tropicana's Fountain Theatre from 1959 to 1975. The Fountain Theatre was billed as "one of the world's most magnificent showrooms." Displaying pink architectural elements, furnishings, and stage curtains, the venue was nicknamed "the pink room." The unique proscenium stage included a *passerelle* (bridge) that extended out and into the audience via a ramp that encircled the orchestra pit, affording the audience a detailed view of the performers and their costumes. Positioned at either wing of the stage were stairs leading

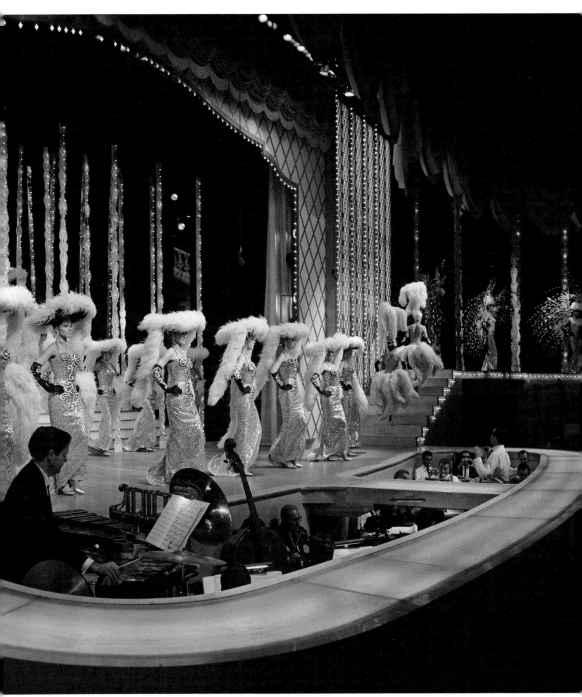

to elevated and curved platforms. This panoramic presentation resulted in a theater experience that was intimate, enchanting, and breathtaking. The open orchestra pit would prove to be so precarious for the performers that, eventually, a prophylactic net was installed to catch the cast when one of them inadvertently stepped off the stage, slipping into the pit. The distinctive features of the *Folies Bergere* showroom are seen in this interesting photograph from 1962. (Courtesy of Las Vegas News Bureau.)

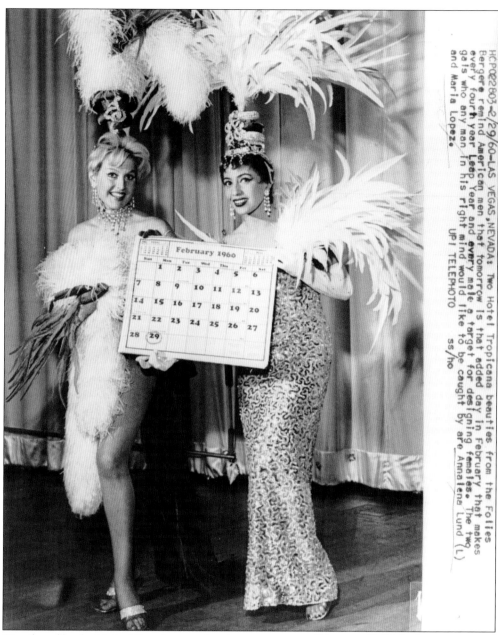

Distributed by the United Press International news agency on February 29, 1960, this promotional photograph was accompanied with the caption, "Two Hotel Tropicana beauties from the *Folies Bergere* remind American men that tomorrow is that added day in February that makes every fourth year Leap Year and every male a target for designing females. The two gals who any man in his right mind would like to be caught by are Annalena Lund (L) and Maria Lopez." A few months earlier, Maria Lopez had been singled out in a photograph that appeared in the *Las Vegas Sun* newspaper. The caption reads, "In a fabulous and sensational opening of Mons. Paul Derval's *Folies Bergere* at the Hotel Tropicana, a bundle of Parisian personality, Maria Lopez, was one of the outstanding features of the show." (Courtesy of Nevada State Museum, Las Vegas.)

In an interview with the *Las Vegas Sun* newspaper, Marjorie Fields recalls working as a cast member in the show during the early 1960s: "It was a time when the showgirls were expected to hang around in the lounge after a show and maybe go to dinner in the Gourmet Room with a fan." This photograph was taken in 1963. (Courtesy of Don English/Las Vegas News Bureau.)

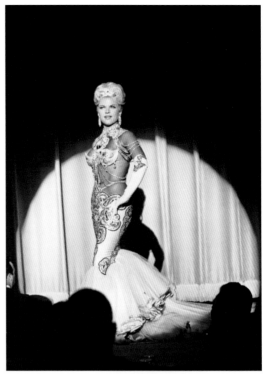

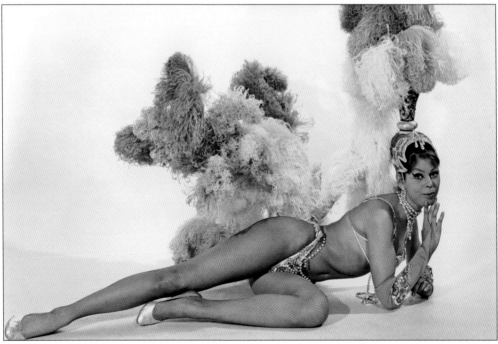

The cabaret does not limit itself to a single type of feminine beauty. Slender, robust, and athletic forms are all part of the malleable formula. Physical attraction, charm, and charisma were indispensable characteristics of the women of the *Folies Bergere*. This photograph features a lovely showgirl posing for Rob Gubbins's camera in the mid-1960s. (Photograph by Rob Gubbins.)

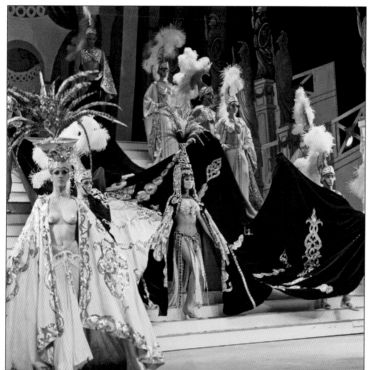

In this photograph from 1963, principal showgirl Felicia Atkins navigates the staircase at center stage in the number "Le Manteau Imperial." Atkins's colossal imperial robe draped the length of the staircase and required the support of a handful of showboys. (Courtesy of Don English/Joe Buck/John Cook/Las Vegas News Bureau.)

The 1964 movie classic *Viva Las Vegas*, starring Elvis Presley and Ann-Margret, includes a scene filmed in the Fountain Theatre with the *Folies Bergere* cast. This photograph details one of the headdresses seen in the movie and is a splendid example of Michel Gyarmathy's signature ornate embellishment. The immense headdress is included in the permanent collection at the Clark County Museum. (Author's collection/Clark County Museum.)

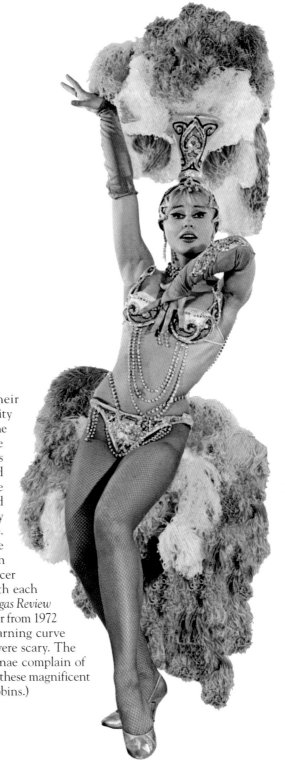

Showgirls are skilled in displaying their exquisitely decorated costumes with dignity and poise. This *Folies Bergere* dancer from the early 1960s strikes the iconic bevel stance of the showgirl. The standing position is achieved with the front knee bent and pulled inwards to the centerline of the body and the forward toe pointed and facing front. The position creates a very flattering, feminine, and sinuous silhouette. Exaggerated costume pieces, such as the feather headdress and feather bustle seen in this photograph, require that the dancer recalibrate their body's personal scale with each change of costume. As quoted in the *Las Vegas Review Journal*, Anita King, wardrobe crew member from 1972 to 1980, describes a newbie showgirl's learning curve concerning sizeable headdresses: "They were scary. The girls had to practice forever." Many alumnae complain of neck discomfort resulting from the scale of these magnificent costume pieces. (Photograph by Rob Gubbins.)

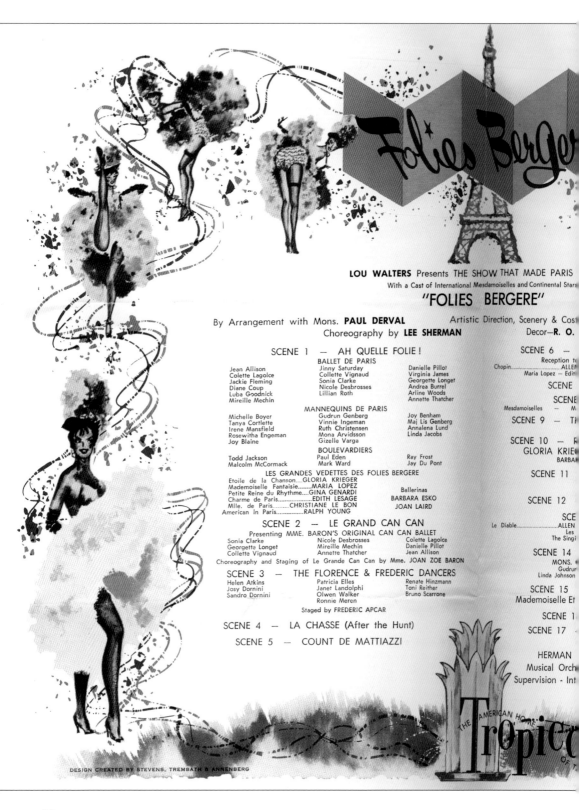

LOU WALTERS Presents THE SHOW THAT MADE PARIS

With a Cast of International Mesdamoiselles and Continental Stars

"FOLIES BERGERE"

By Arrangement with Mons. **PAUL DERVAL** Artistic Direction, Scenery & Cost

Choreography by **LEE SHERMAN** Decor—**R. O.**

SCENE 1 — AH QUELLE FOLIE!

BALLET DE PARIS

Jean Allison	Jinny Saturday	Danielle Pillot
Colette Lagolce	Collette Vignaud	Virginia James
Jackie Fleming	Sonia Clarke	Georgette Longet
Diane Coup	Nicole Desbrosses	Andrea Burrel
Luba Goodnick	Lillian Roth	Arline Woods
Mireille Mechin		Annette Thatcher

MANNEQUINS DE PARIS

Michelle Boyer	Gudrun Genberg	Joy Benham
Tanya Cortlette	Vinnie Ingeman	Maj Lis Genberg
Irene Mansfield	Ruth Christensen	Annalena Lund
Rosewitha Engeman	Mona Arvidsson	Linda Jacobs
Joy Blaine	Gizelle Varga	

BOULEVARDIERS

Todd Jackson	Paul Eden	Ray Frost
Malcolm McCormack	Mark Ward	Jay Du Pont

LES GRANDES VEDETTES DES FOLIES BERGERE

Etoile de la Chanson....GLORIA KRIEGER	
Mademoiselle Fantaisie.......MARIA LOPEZ	
Petite Reine du Rhythme....GINA GENARDI	Ballerinas
Charme de Paris..................EDITH LESAGE	BARBARA ESKO
Mlle. de Paris.........CHRISTIANE LE BON	JOAN LAIRD
American in Paris..............RALPH YOUNG	

SCENE 2 — LE GRAND CAN CAN

Presenting MME. BARON'S ORIGINAL CAN CAN BALLET

Sonia Clarke	Nicole Desbrosses	Colette Lagolce
Georgetta Longet	Mireille Mechin	Danielle Pillot
Collette Vignaud	Annette Thatcher	Jean Allison

Choreography and Staging of Le Grande Can Can by Mme. JOAN ZOE BARON

SCENE 3 — THE FLORENCE & FREDERIC DANCERS

Helen Atkins	Patricia Elles	Renate Hinzmann
Josy Dornini	Janet Landolphi	Toni Reither
Sandro Dornini	Olwen Walker	Bruno Scarrone
	Ronnie Meren	

Staged by FREDERIC APCAR

SCENE 4 — LA CHASSE (After the Hunt)

SCENE 5 — COUNT DE MATTIAZZI

SCENE 6 —

Chopin.....................	Reception to
	ALLEN
Maria Lopez — Edith	

SCENE

SCENE

Mesdamoiselles — M

SCENE 9 — TH

SCENE 10 — R

GLORIA KRIEG

BARBA

SCENE 11

SCENE 12

SCE

Le Diable.................ALLEN

Les

The Singi

SCENE 14

MONS. C

Gudru

Linda Johnson

SCENE 15

Mademoiselle Et

SCENE 1

SCENE 17

HERMAN

Musical Orch

Supervision - Int

Mons. **MICHEL GYARMATHY**
ORN

SOIREE ROMANTIQUE
Chopin — Paris 1850
Hortense Schneider......GLORIA KRIEGER
ristiane Le Bon — Gizelle Varga

RIO BARENTON

MARIA LOPEZ
— Boulevardiers — Ballerinas

NCE & FREDERIC BALLET
IGHT ON RUE PIGALLE

MOUR (Romantic Reverie)
RALPH YOUNG
JOAN LAIRD

Y FOR AMERICANS
NARDI

GES LAFAYE & CO.

— L'ENFER
L'InnonenceGIZELLE VARGA
carlet Women)
OLETTE RIEDINGER

PARISIAN ARTIST
His Live Models
Joy Blaine
tkins — Ralph Young

ER WONDERLAND
s........GLORIA KRIEGER

HE THREE KIMS

UMIERES DE PARIS

HIS ORCHESTRA
by RAY SINATRA
n & Special Lyrics by LOU WALTERS

HOTEL
BERGERE

SILVER STATE PRINTERS & ENGRAVERS

This charming show program introduces the *Folies Bergere* to the American audience as "The Show That Made Paris Famous" and further boasts "a Cast of International Mademoiselles and Continental Stars." The program dates from 1960 and details the musical revue's first production in America. Note that Lou Walters receives top billing as the production's producer. Walters is credited as the impresario responsible for securing the rights from Paris to present the *Folies Bergere* in Las Vegas. He also happened to be the father of famed broadcast journalist Barbara Walters. Explaining her father's gamble on the concept of importing the French feather show to the Tropicana stage, Barbara Walters notes, "At first, he wasn't sure it would work, but it turned out to be a tremendous success. The showgirls and chorus girls were beautiful. The costumes were exquisite, and the production had the stamp of class." (Courtesy of Maryann Hernandez Picchi.)

21

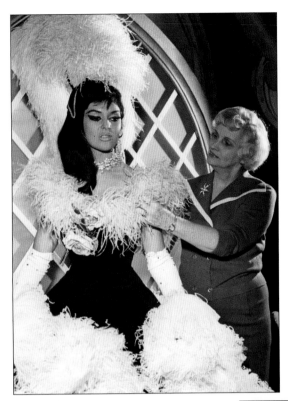

In this photograph, wardrobe mistress Mae Burke attends to showgirl Felicia Atkins. Burke's husband, William Burke Jr., is credited as the show's scenic engineer in 1965. The *Folies Bergere* costumes were designed and built to withstand the rigors of two nightly shows and three shows on Saturday. (Photograph by Rob Gubbins.)

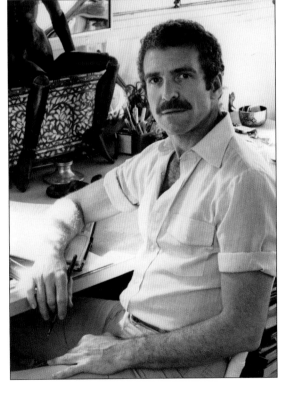

Jerry Jackson began his working relationship with the *Folies Bergere* in 1966 and is a captain of this art form. At varying times throughout the show's history, Jackson served as choreographer, creative director, costume designer, and composer. Jackson began his career in the entertainment industry as a professional dancer. This background provides a fundamental appreciation of both the opportunities and limitations concerning the design of dance costumes. (Courtesy of Jerry Jackson.)

Michel Gyarmathy served as artistic director of the *Folies Bergere* in Las Vegas from 1959 to 1974. Throughout his long career with the production, Gyarmathy additionally worked as set designer, graphic artist, and costume designer. This photograph was taken during rehearsals at the Hotel Tropicana before the show's debut in late 1959 and shows Gyarmathy (right) seated at the piano working through a musical number with a singer. (Courtesy of Joe Buck/Jerry Abbott/Las Vegas News Bureau.)

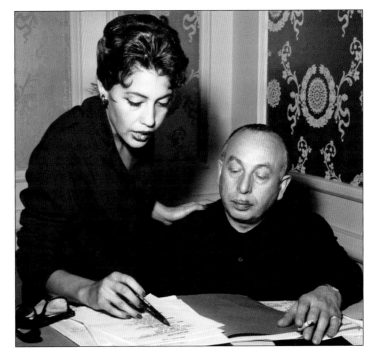

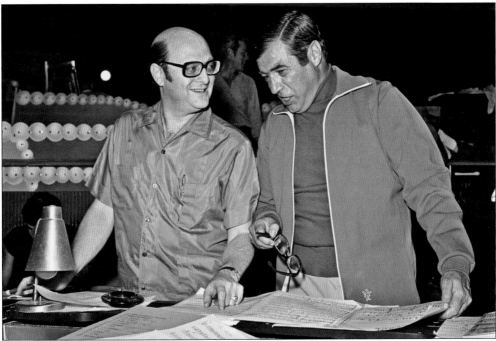

Here, *Folies Bergere* producer Maynard Sloate and orchestra conductor Si Zentner confer at the piano during show rehearsals in 1968. Before signing on with the *Folies Bergere*, Si Zentner wielded his baton as a popular and successful big band leader and earned a Grammy Award in 1962. (Courtesy of Milt Palmer/Las Vegas News Bureau.)

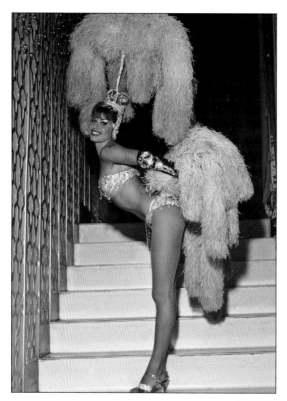

The splendor of the headdress is a distinctive characteristic of the showgirl costume. Simultaneously spectacular and harrowing, it is not unusual for a headdress to measure four feet in height. As a result, many showgirls have an amusing "wardrobe malfunction" tale to tell involving a headdress. Among these are accounts of headdresses getting caught up in the stage curtain and tangled in another dancer's costume. (Courtesy of Milt Palmer/Las Vegas News Bureau.)

The Hotel Tropicana advertised its property as the "American home of the *Folies Bergere*." In 1959, in a review of the new show, the *Las Vegas Sun* newspaper reported, "From Chopin to Can-Can, all phases of the theatre are covered in an hour and a half of entertainment that becomes more delightful and intriguing as scenes unfold." (Author's collection.)

The Hotel Tropicana presented the *Folies Bergere* twice nightly; the early show served dinner, and the late show began at 10:30 p.m. and offered cocktail service. This early-1970s snapshot features Maryann Hernandez Picchi dressed in an 18th-century-inspired costume. (Courtesy of Maryann Hernandez Picchi.)

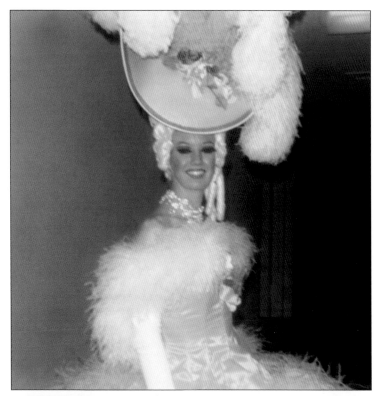

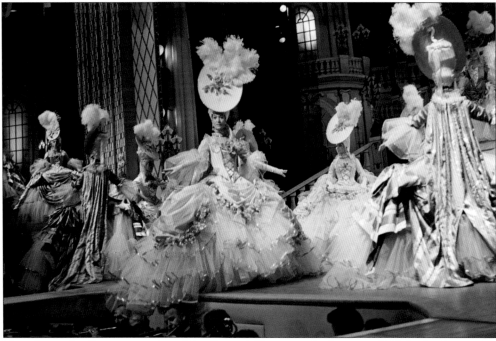

Note the perils of being a member of Ray Sinatra's Tropicana Orchestra in 1962. In this fascinating shot, it is evident that the stage is unable to contain the showgirl's enormous character costume, and the excess yardage finds its way into the orchestra pit. (Courtesy of Las Vegas News Bureau.)

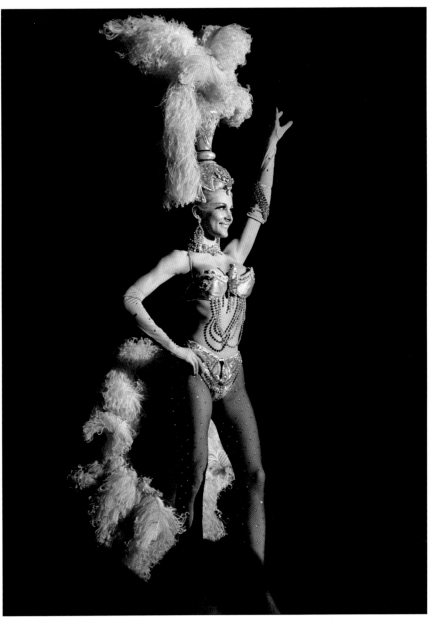

The difference between a chorus girl and a showgirl in the early 20th century was well defined. A chorus girl could dance and could sing a little, and a showgirl strictly "showed." Early showgirls, also called mannequins, were responsible for showing off beautifully made garments with the greatest of style and panache. The distinctions between these roles are now blurred, as modern showgirls are required to have professional dance training in addition to their "showing" skills. The first "nude" or topless showgirls were not permitted any consequential movement onstage. They were non-dancing "frozen beauties." So-called nude showgirls are not, in fact, nude. As *Folies Bergere* producer Paul Derval asserts, "The wearing of a diminutive triangle of fabric is still de rigueur." This striking photograph features a feathered creature from the 1964 *Folies Bergere* show. The showgirl's magnificent costume includes both a bustle and headdress that display an abundance of ostrich plumes. (Courtesy of John Cook/Don English/Joe Buck/Las Vegas News Bureau.)

Two

A SEQUINED SENSATION AND A LAS VEGAS ICON

THE SHOWGIRL

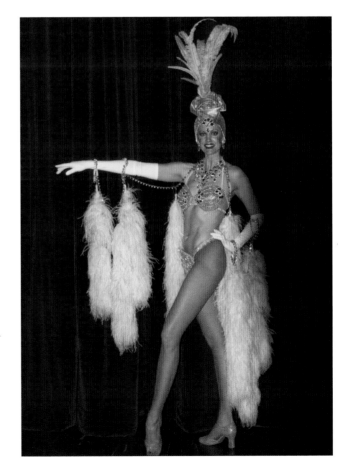

Often employed as civic ambassadors, *Folies Bergere* cast presided over community affairs and added a bit of razzle-dazzle to local ceremonies. In this photograph, showgirl Kirsten Wolner wears a costume specifically designed by Jerry Jackson in the early 2000s for use in such offstage publicity events. (Courtesy of Angela Santangelo.)

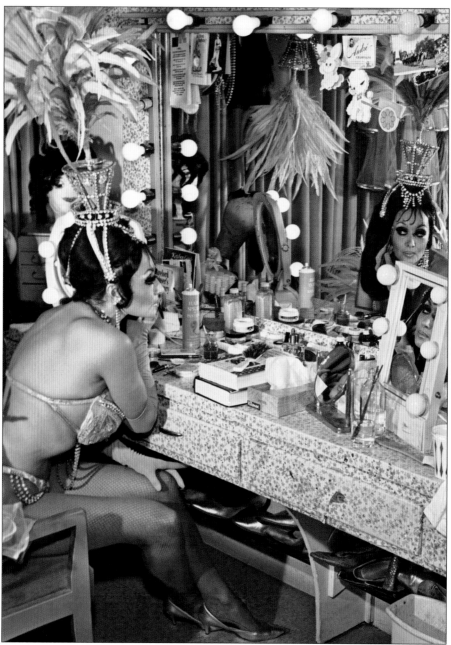

Many performers traveled to Las Vegas from all over the world to dance with the *Folies Bergere*. These folks settled in Las Vegas and endeavored to establish a foundation for their future. Their good fortune was that while earning a living they were doing something that they absolutely loved. Ginny Murphy was affiliated with the production in varied capacities for many years and describes the sentiment of the *Folies Bergere* cast: "People in our show are here because they have a passion for performing. They do not come here to get rich." In this photograph from 1970, lead showgirl Joyce Grayson is seen preening at her backstage dressing table. After Grayson retired from dancing, she transitioned to a position in the wardrobe department of another Las Vegas Strip production show, *Jubilee*. (Courtesy of Wolf Wergin/Las Vegas News Bureau.)

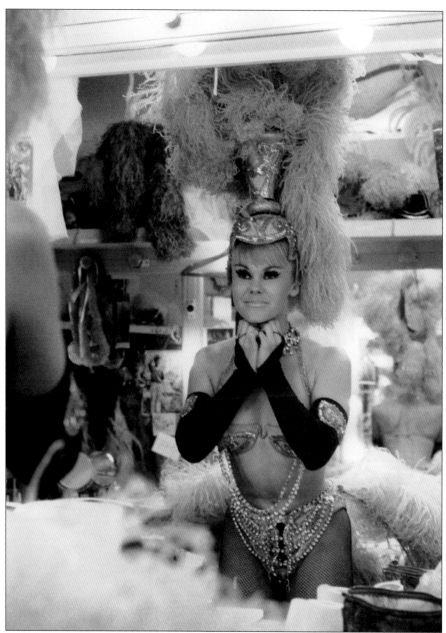

Folies Bergere dancer Vicki Pettersson describes how she got into the business: "I was tall and grew up in Las Vegas, and so instead of 'You should be a model,' it was 'You should be a showgirl.'" Many dancers took advantage of the profession's evening schedule by attending school during the day. *Folies Bergere* dancer Karen Marentic explained in an interview with a local magazine, "When I first got into the show, it was to pay for [an] education. It was a wonderful experience. I could dance at night and make enough money to go to school." "I really love the job," notes showgirl Diane Gibson in an article from 1982. "You've never met a combination of girls like the fourteen we have in our dressing room. I've never had any sisters, and you're in this room and you have thirteen sisters." In this photograph from 1964, a showgirl fastens her headdress into place as she prepares for showtime. (Photograph by Rob Gubbins.)

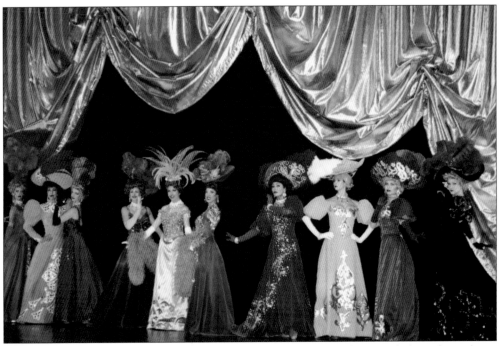

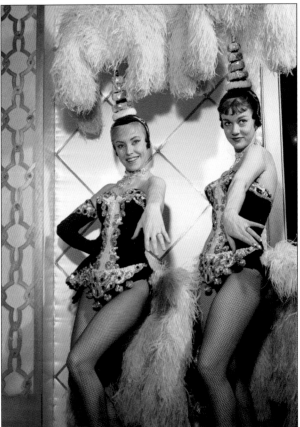

This photograph from the early 2000s features *Folies Bergere* showgirls costumed in stunning 19th-century gowns used in the opening number of "La Belle Epoque." Pictured onstage are, from left to right, Kirsten Wolner, Kristine Perchetti, Rosemarie Caspary, Lucy Fauchon, Trish Willis-Randall, Denise Rapuano, Janu Tornell-Ferraro, Cari Byers, Julia Kolyadenko, and Vicki Pettersson. (Courtesy of UNLV Libraries Special Collections.)

Included in the *Folies Bergere* cast are "swing dancers." These performers have memorized all the parts in the show and are able to swing between various positions to replace a dancer during an emergency or a vacation day. In this photograph from 1960, two bewitching dancers show off their engagement rings. (Courtesy of Las Vegas News Bureau.)

Typically jumping from one short-term gig to the next, the entertainment industry is not known for providing steady work, but a job with the long-running *Folies Bergere* offered actual security. Cast and crew could raise families while earning a decent living. Remarkably, some women continued dancing during their pregnancies and returned to the show following just a brief maternity leave. (Courtesy of Wolf Wergin/Las Vegas News Bureau.)

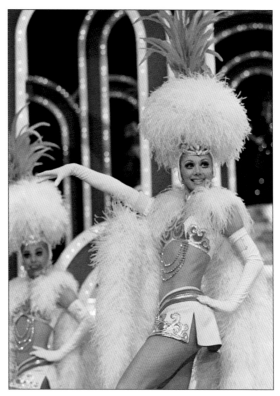

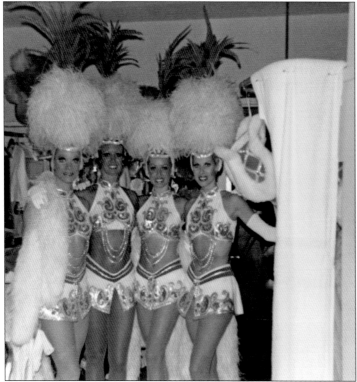

The ladies seen in this dressing-room photograph are, from left to right, Barbara Richards, Maryann Hernandez Picchi, Shelia Ahey, and Evelyn D'Elia Kitt. These costumes are seen onstage in the previous photograph from 1971. (Courtesy of Maryann Hernandez Picchi.)

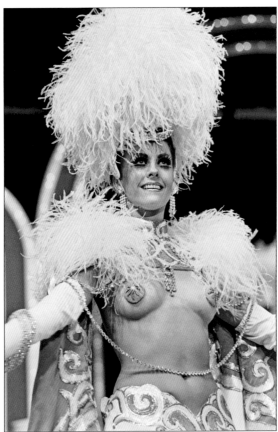

"Every act is terrific and magnificently produced in rare good taste. There are nudes but not just the standing around kind. These are occupied nudes guaranteed not to offend anyone's sensibilities," explains Hank Greenspun in a 1959 newspaper column about the debut performance of *the Folies Bergere*. In 1969, a magazine review stated, "One of the most impressive things about the new *Folies* is its tasteful handling of nudity. There is no nudity for the mere sake of nudity itself and even the famous *Folies* mannequins are not completely topless." The photograph at left, from 1971, features a time-honored ornament of the cabaret costume genre known as a pastie. These decorative nipple "garments" were often seen on the *Folies Bergere* stage. Featured in the photograph below is a set of pasties included in the collection at the Nevada State Museum, Las Vegas. These pasties were donated to the museum and worn by *Folies Bergere* showgirl Kathleen Manley. (Left, courtesy of Wolf Wergin/Las Vegas News Bureau; below, author's collection/ Nevada State Museum, Las Vegas.)

This dressing-room snapshot from 1971 affords a preview of Maryann Hernandez Picchi's other assorted costumes awaiting their turn on the stage. Picchi performed in the show for 10 years, from 1970 to 1980. She was married to George Hernandez, credited as the show's orchestra conductor from 1973 to 1974. (Courtesy of Maryann Hernandez Picchi.)

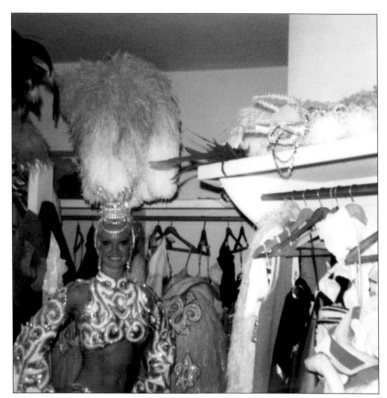

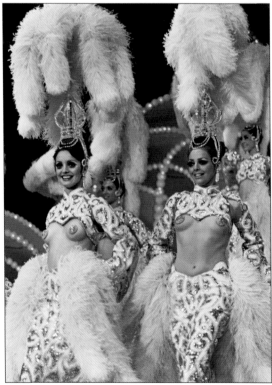

Performer Diane Gibson explains, "When I started, there was so much stage fright that I never had time to think about being topless, but to some girls it's a big deal. Their boyfriends or husbands don't want them to be topless, or they just don't want it themselves." Pictured in the front row of this photograph from 1971 are Eva Nolan (left) and Susanne Kaime Reese. (Courtesy of Wolf Wergin/Las Vegas News Bureau.)

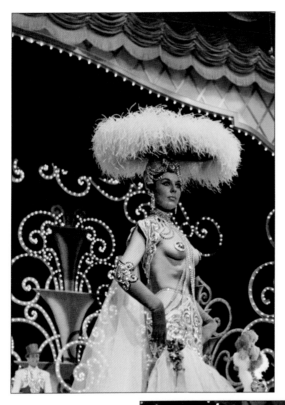

Adagio dancer Gail Eason describes her mother's reaction upon seeing her *Folies Bergere* performance: "My mother loves it. She looked at the show, and she said to me, 'You know, you really hardly realize that you don't have much on. It all looks so pretty.'" In this photograph from 1963, pasties are strategically fitted onto the breast to enhance and direct attention to the bosom. (Courtesy of Milt Palmer/Las Vegas News Bureau.)

"For stagehands," writes reporter Gary Dretza, "frequent exposure to dozens of pairs of breasts at a time is just part of the job. 'It's like working at a bank and having to handle money all the time,' says [*Folies Bergere* stagehand] Alfred Bash; 'You get used to it.'" In this photograph from 1969, "nude" showgirls garnish the stage. (Courtesy of John Cook/Las Vegas News Bureau.)

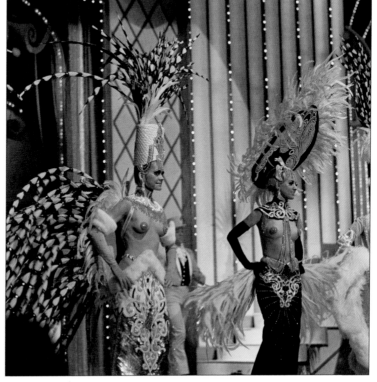

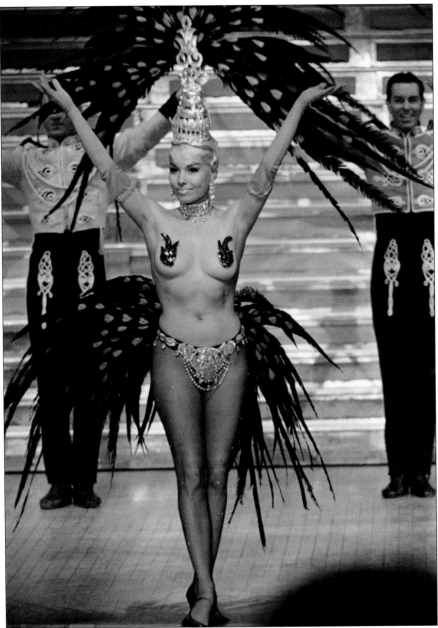

Maynard Sloate, *Folies Bergere* producer from 1968 to 1972, recalls in the *Las Vegas Sun* newspaper that "the costumes were made by little old ladies around Paris, and then shipped over to Las Vegas. Now, the law said you could bring it (sets and costumes) in duty-free, but only for three years. After that, you had to either pay duty, which was half its value, or get rid of it. You could either send it back, or you could burn it. So with a customs agent watching, every three years we'd go into the desert to burn them. My co-producer, who produced the *Folies* in Paris, watched once and cried." The aforementioned coproducer is Michel Gyarmathy. The elaborate pasties seen in this photograph from the 1962 edition of the show were embellished with sequin work and glued onto the body employing the same type of adhesive the showgirls used to attach their false eyelashes. (Courtesy of Jerry Abbott/John Cook/Las Vegas News Bureau.)

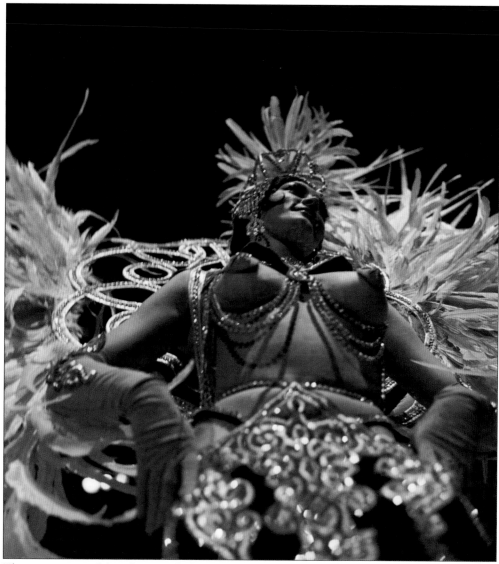

The perspective of this photograph from 1964 provides a fascinating view of the many layers of ornament typical on Michel Gyarmathy's costumes for the *Folies Bergere*. His keen calculation regarding the covered and uncovered parts of the female form is a distinctive feature of his style. The intent is to adorn the female form rather than to merely reveal it. Titillation without offense requires a fine-tuned eye and hand. Bird feathers are a traditional design element of the cabaret costume genre. Strategically placed plumes can create dramatic scale to a costume without adding a dramatic amount of additional weight. The inherent lightness of the material makes for an ideal embellishment on dance costumes. Onstage, feathers appear to be in a continual state of flight even while the dancer is at a standstill. (Courtesy of John Cook/Don English/Joe Buck/ Las Vegas News Bureau.)

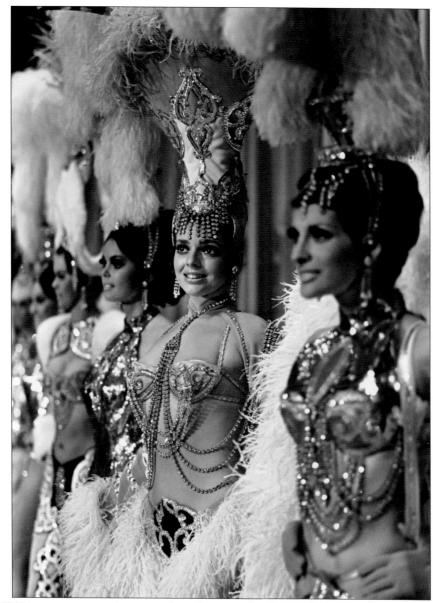

This 1969 image presents a decorative frieze featuring the elegant, delicate, and highly embellished costume work of Michel Gyarmathy. The headdress seen at far right is designed around a metal headband-style frame. This style of headdress revealed the dancer's hair and was secured to the head using a few strategically placed French wire hairpins. Other headdresses, such as that seen second from the right, were designed around a substantial skullcap foundation and offered more coverage of the hair and head. Most all the headdresses required a flesh-color under-the-chin strap to maintain the position of the piece atop the head. It is not surprising that these resplendent costumes were designed and built in a city made famous for the art of the dress and undress, Paris. Many of the specialty artisan trades that support the haute couture industry in Paris are utilized in the making of cabaret costumes. Pictured third from the right is showgirl Debbie Lee. Lee was married to the Hotel Tropicana's entertainment director and executive producer, Larry Lee. (Courtesy of Joe Buck/Las Vegas News Bureau.)

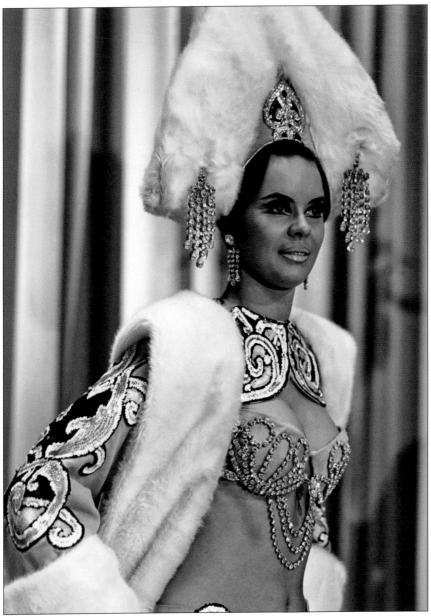

Although the imported *Folies Bergere* sets and costumes were routinely destroyed following the conclusion of each edition of the production, some costumes did survive these heartbreaking bonfires. One such survival story is found in a Midwestern American costume shop where a grouping of retired stage costumes from the early 1970s ended up. The owner explains why the costume purchase was valuable for the business: "Most were taken apart for the French patterns or disassembled for the horse hair used in construction [which is] no longer available on the market. Headpieces and backpacks for showgirls were constructed differently throughout the years making some of them useful for the welders to learn [how to construct] the needed support bars." Through the early 1970s, the destruction of the show's sets and costumes generally occurred in the Hotel Tropicana's "backyard," which at that time was just called "the desert." This photograph was taken in 1969. (Courtesy of Joe Buck/Las Vegas News Bureau.)

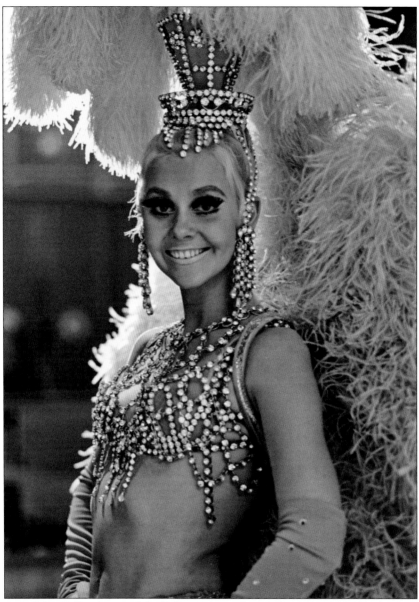

In a review of the 1969 edition of the *Folies Bergere*, the production received a clever epicurean assessment: "Three master chefs of the entertainment world have whipped-up a magnificent $750,000 soufflé that will at once dazzle your mind, delight your eye, and demolish all your senses with its stunning beauty . . . The chefs are producers Michel Gyarmathy and Maynard Sloate and choreographer Tony Charmoli." Dancer Stevi Danik LaSpina is pictured in 1969 wearing a brassiere composed entirely of silver plated crystal chain link trim. Each individual rhinestone on the linear trim is encased in a Tiffany mount within a metallic linking system. Some of the rhinestone chain link elements are attached to a wire foundation while others are designed to drape around the curvatures of the female form and to freely move in unison with the dancer. This material is very long lasting and dazzling yet difficult to alter and repair. When any maintenance is called for, the expertise of a seamstress, a solderer, and a welder are required. (Courtesy of Joe Buck/Las Vegas News Bureau.)

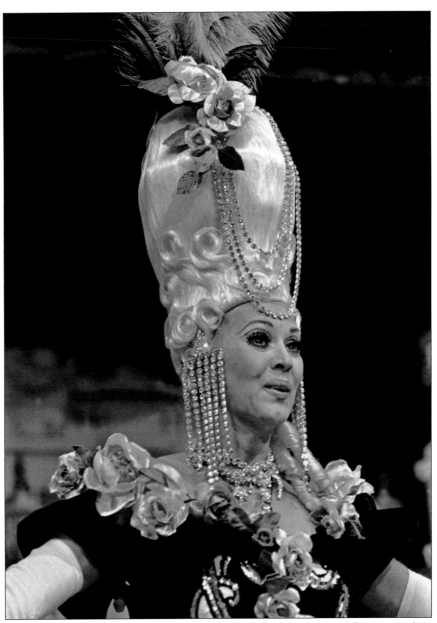

A souvenir postcard promoting the production reads, "The spectacular *Folies Bergere* brings the excitement of Paris and the brilliant talents of international performers to the stage of Hotel Tropicana, Las Vegas. Each year a new edition of this princely production bows to brighten the entertainment scene in the show business capital of the world." This photograph dates from the 1971 edition and features Carolynn Everette as seen in the number titled "Reception Chez Napoleon III." Her costume, including the impressive "pouf" headdress, was designed by Michel Gyarmathy and represents a reliable theme employed in the cabaret genre that exploits visually significant historical fashion trends. A favorite historic era of the *Folies Bergere* was 18th-century France. The show's various creative teams staged acts depicting the French royal court at the Palace of Versailles in at least three separate editions of the production. (Courtesy of Gary Angell/ Las Vegas News Bureau.)

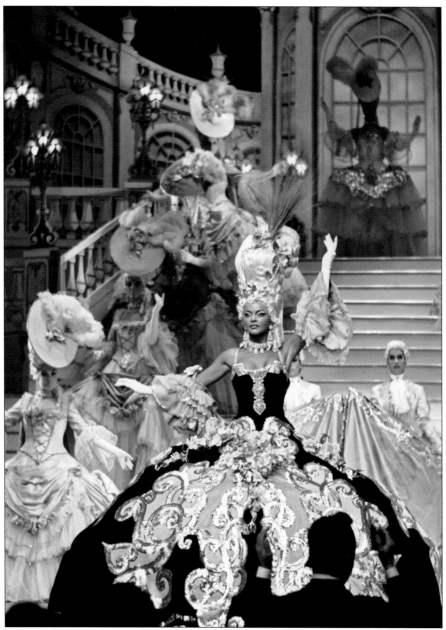

Showgirls are not always scantily clad. Typically, cabaret costumes are quite elaborate, with various parts and pieces making up the complete ensemble. The complexity and scale of the costumes require that the performers have assistance from one or more wardrobe department "dressers" to get into and out of each scene's costume. The *Folies Bergere* wardrobe department included about 18 crew members. The scene featured in this photograph, titled "Réception à Versailles," provided an opportunity to recreate French court fashion of the 18th century. The fashionable silhouettes of this distinctive period are inherently ripe for caricature on the stage. The grand gown seen at center stage in this photograph from the 1963 edition of the *Folies Bergere* includes an enormous train attended to by a few debonair showboys. (Courtesy of Don English/Las Vegas News Bureau.)

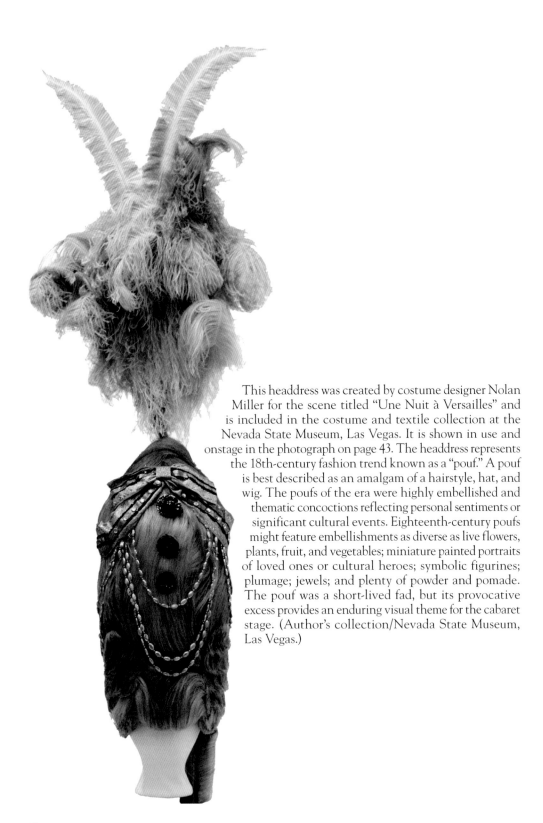

This headdress was created by costume designer Nolan Miller for the scene titled "Une Nuit à Versailles" and is included in the costume and textile collection at the Nevada State Museum, Las Vegas. It is shown in use and onstage in the photograph on page 43. The headdress represents the 18th-century fashion trend known as a "pouf." A pouf is best described as an amalgam of a hairstyle, hat, and wig. The poufs of the era were highly embellished and thematic concoctions reflecting personal sentiments or significant cultural events. Eighteenth-century poufs might feature embellishments as diverse as live flowers, plants, fruit, and vegetables; miniature painted portraits of loved ones or cultural heroes; symbolic figurines; plumage; jewels; and plenty of powder and pomade. The pouf was a short-lived fad, but its provocative excess provides an enduring visual theme for the cabaret stage. (Author's collection/Nevada State Museum, Las Vegas.)

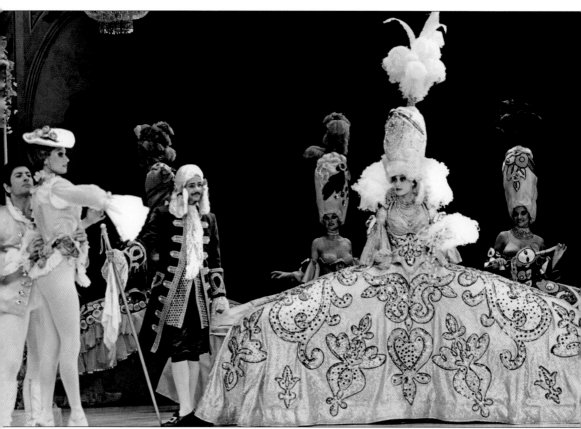

"Une Nuit à Versailles" is the title of a scene from the 1980 "revision-edition" of the *Folies Bergere* that imagined the life of Marie Antoinette, the queen of France, during an evening with the royal court at the Palace of Versailles. A revision-edition indicates that the entire show was not replaced but that only a few strategic numbers from the show were revised. The immense costume seen in this photograph measures nearly nine feet in width. With eight of this type of costume onstage at once, *Folies Bergere* creative director Jerry Jackson jokes that the proceedings backstage were as entertaining, if not more so, than the onstage performance. Thwarting collision between members of the dressed cast required meticulous choreography that was especially crucial during performers' entrances and exits. Seen in the front row of this photograph are, from left to right, Aleco Balsas, Terri Martin, William Garbett III, and Lydia Farrington-Jenkins. (Courtesy of UNLV Libraries Special Collections.)

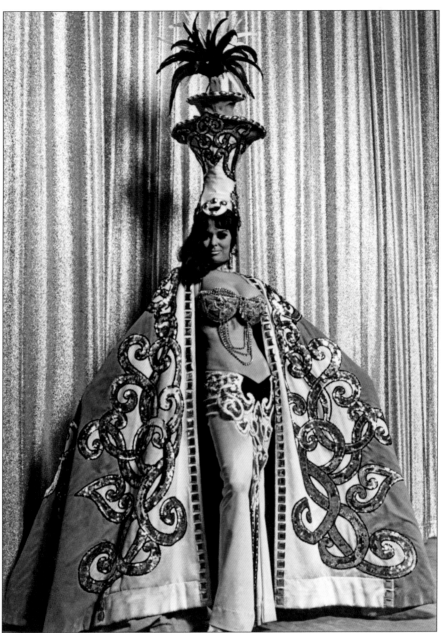

Columnist Jack Sheehan with the *Las Vegas Review Journal* newspaper writes, "Felicia Atkins . . . was the most publicized showgirl in Las Vegas history. Felicia represented to the world everything it thought a showgirl should be, and more. With her raven dark hair, dark eyes, full lips, and overwhelming bosom, Felicia was the essence of the unattainable goddess the guy from Topeka would take home in his dreams." Atkins toured the country in promotion of the stage show and was the face of the production during her 18.5-year reign. She recalled what it was like to be a Las Vegas showgirl: "Everywhere I went I was treated like a movie star, a queen. The showgirl in those days was very well-respected. I was always made to feel like somebody special." In this photograph, Atkins is seen in her extravagant costume for the number titled "1000 and Two Nights." (Courtesy of UNLV Libraries Special Collections.)

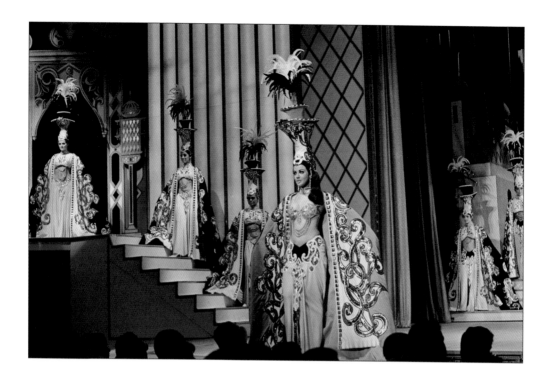

This photograph from 1969 was taken during the memorable number "1000 and Two Nights." The costumes designed for this act featured towering headdresses inspired by the Hotel Tropicana's signature water fountain located at the hotel's entrance. The property's company logo featured the iconic fountain and is shown in the illustration below. These spectacular "fountain" headdresses were notoriously difficult to balance on the head. Dancer Sheri Bartlett Mirault notes that it took her a few weeks of trial and error to figure out how to keep the headdress from toppling off her head. Mirault additionally recalls that her position of entrance for this number was atop one of the elevated wraparound wings of the stage. To get into proper position, she had to climb a vertical ladder positioned behind the raised stage. She maintains that the execution of this precarious entrance, in full costume and including high heeled shoes, was a much more complex undertaking than was her onstage choreography for the number. (Above, courtesy of Wolf Wergin/Las Vegas News Bureau; below, courtesy of Rio Clehr Nole.)

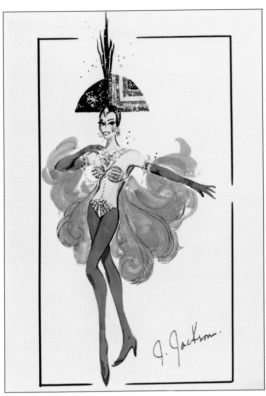

This costume rendering dates from 1983 and perfectly illustrates Jerry Jackson's mastery of color, scale, and silhouette for the stage. Jackson contracted Hedy Jo Star's Las Vegas establishment to build many of the costumes designed for the 16th edition of the show. A 1983 press release for this edition of the *Folies Bergere* describes the vast quantities of materials employed: "Just in the can-can number alone, there are over 1,500 yards of fabric in the dresses. A total of 20,000 yards of ruffles were utilized to line the inside of the full-skirted [can-can] costumes. In the opening number, 50 thousand yards of sequins were sewn onto the showgirl gowns and dancer costumes." Shop proprietor Star declared that "these are the best costumes I've ever seen and I think they'll be the most glamourous in the whole city!" The costume featured in this sketch is seen realized and onstage in the black-and-white photograph below. (Left, courtesy of UNLV Libraries Special Collections; below, courtesy of Gary Angell/Las Vegas News Bureau.)

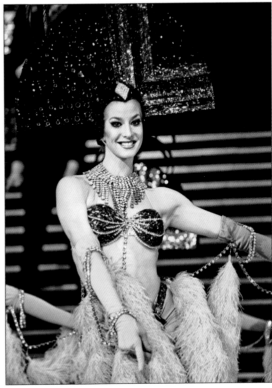

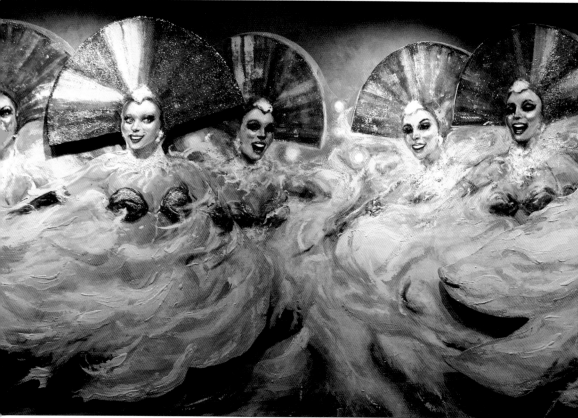

Located at Las Vegas's McCarran International Airport, "Folies in Flight" is a part of the venue's permanent "Airport Art" installation. Created in 2012 by former showgirl Terry Ritter and spanning 50 feet in length, the animated and playful mural celebrates the spirit of the city's legendary *Folies Bergere* show. During production of the piece, Ritter engaged *Folies Bergere* dancers to serve as models for her painting and based the theme of the work on the opening scene of the 16th edition of the show. She proudly asserts that "the mural is one of the first experiences for international travelers when they arrive in Las Vegas and is one of the focal points of the terminal." This photograph features a detailed view of one section of the impressive artwork. The costumes featured in the painting are seen on page 46. (Photograph by Jeff Scheid.)

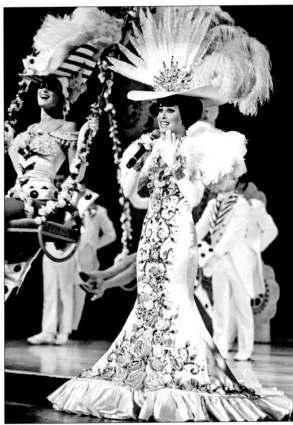

This photograph features songstress Lynette Giesen (right) and dancer Joan Chamberlin (seen on the swing) in the 16th edition of the show. The scene "Le Music Hall de Paris: 1900s" portrayed an evening in Paris at the turn of the 20th century with the lead singer performing an operatic aria. (Courtesy of UNLV Libraries Special Collections.)

"Everyone got along. It was like a family there. We went through marriages, divorces, children being born, people dying, everything like that, it was one great big family for a long time," recalls wardrobe supervisor Kathy Kieffner about the show's cast and crew. Acrobatic dancers and wardrobe department crew pose for this photograph taken on the "Souvenir de Paris" stage setting. (Courtesy of Christa Roper Kuenstler.)

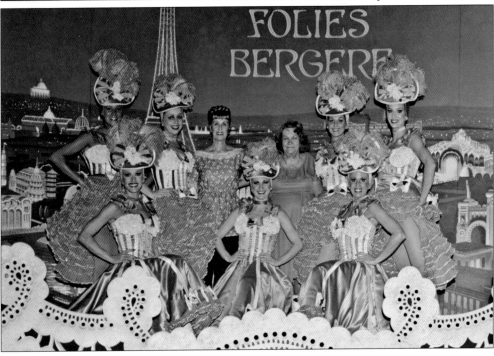

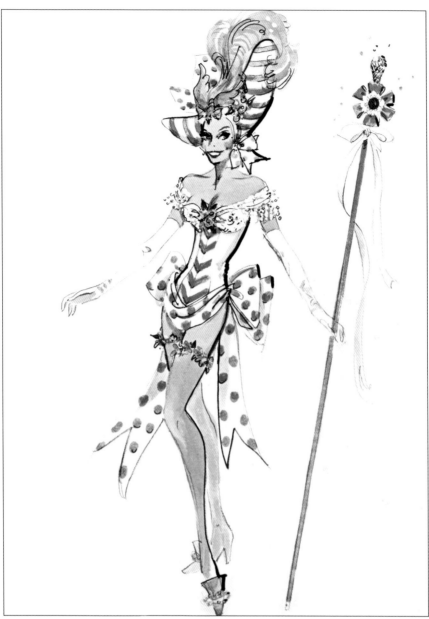

This costume was seen in "Le Music Hall de Paris: 1900s." The set design for this scene included suspended swings that floated from the stage out toward the audience. Charles Lisanby designed the scenery for this edition of the *Folies Bergere*. Lisanby enjoyed a spectacular career in production design for stage and television and is well respected for his lavish sets produced during the golden age of television's variety specials. Lisanby was nominated for 10 Emmy Awards, winning three of the coveted honors. This sketch was created for the 16th edition of the show and represents a "glamour sketch." This is a finalized rendering, a work of art, that designer Jerry Jackson has spent quite a bit of time perfecting. This sketch would typically be presented to the show producers and other creatives on the team. Dancer Nancy Hardy notes that the cast's nickname for this showgirl costume was "Bo Peep." Note how the costume adds further height to an already statuesque showgirl. (Courtesy of UNLV Libraries Special Collections.)

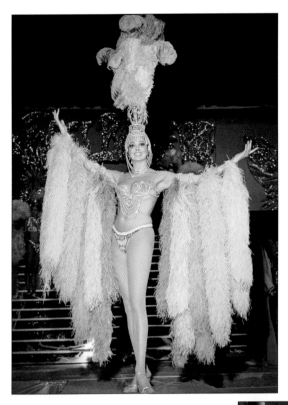

The feathery cabaret costume worn in this photograph by showgirl Marya Linero was designed by Nolan Miller for the 1975 edition of the show. This edition, titled "Le Music Hall," is particularly significant as it marked a permanent move for the *Folies Bergere* from the original Fountain Theatre to the Tropicana's new Tiffany Theatre. (Courtesy of Las Vegas News Bureau.)

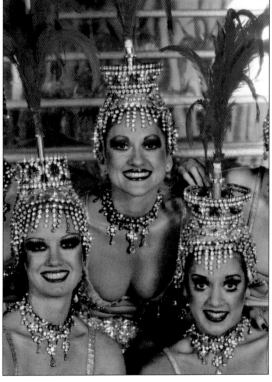

These glittering rhinestone headdresses were designed to accommodate a quick change of plumage. A simple tube holds the feather array in place making for an effortless switch between feather styles and colors. The *Folies Bergere* performers pictured in this mid-1970s photograph are, from left to right, Maryann Hernandez Picchi, Rio Clehr Nole, and Leslie Cook. (Courtesy of Rio Clehr Nole.)

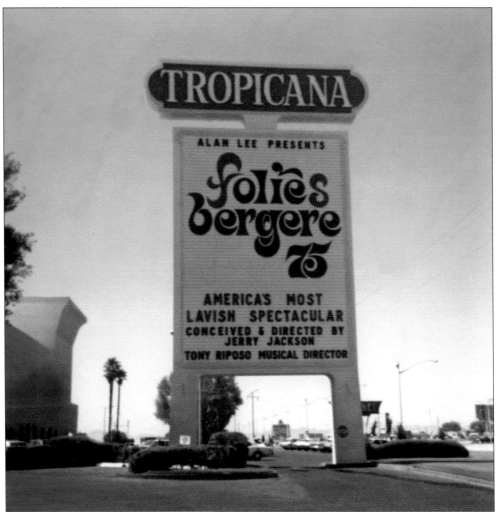

In 1975, when, for the first time, the creative direction of the show was controlled by Americans, the *Folies Bergere* transitioned from a French import to a homegrown production. A local review of this Americanized edition of the *Folies Bergere* reads, "The old *Folies Bergere* has gone from Las Vegas. It was the passing of an era. No more will dancers, in rehearsals, be treated to the sight of Michel Gyarmathy promenading solemnly in front of his mannequins, demonstrating a stately walk that put most of them to shame. The new *Folies Bergere* '75 is conceived and directed by Jerry Jackson and . . . is a remarkable beginning." The *After Dark* magazine review further compliments Jackson: "His use of camp, characterization, and staging makes the new *Folies* a show that is lively and entertaining and brings a touch of theater to the world of cabaret." (Courtesy of UNLV Libraries Special Collections.)

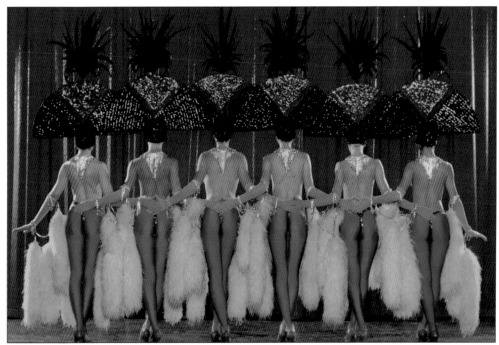

Performers were required to maintain a consistent body weight during their employment with the *Folies Bergere*. The ideal weight was recorded on the day the performer signed their contract with the show. If they strayed too far from the original weight number, Hotel Tropicana management would issue a "Personal Appearance Notice" or a "Warning Slip," as seen in the next photograph. (Courtesy of UNLV Libraries Special Collections.)

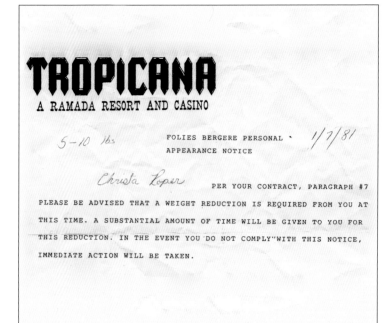

This personal appearance notice from 1981 advises acrobat Christa Roper, "Per your contract, paragraph #7, please be advised that a weight reduction is required from you at this time. A substantial amount of time will be given to you for this reduction. In the event you do not comply with this notice, immediate action will be taken." (Courtesy of Christa Roper Keunstler/ Nevada State Museum, Las Vegas.)

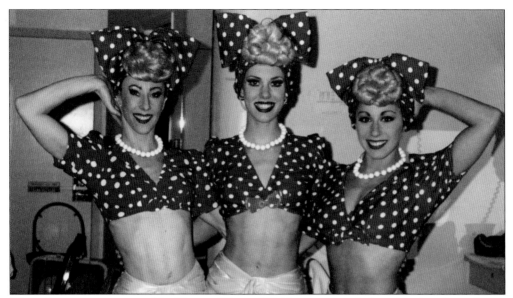

These dancers are costumed for "Boogie Woogie." Publicity materials describe what the audience could expect to see in this act: "Wurlitzer Juke Boxes from the swinging 1940s come to life in a bright musical number featuring pompadoured girls and dancing sailors." The performers seen in this photograph are, from left to right, Leanne Gunther-Fox, Tami Bruening Divich, and Stephanie Webb. (Courtesy of Kathy Kieffner/Nevada State Museum, Las Vegas.)

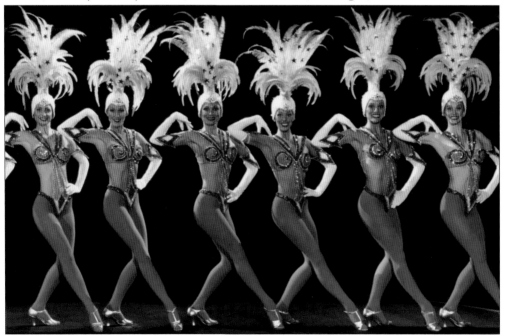

This promotional photograph features dancers wearing a composite costume. The headdresses were designed in 1997 for "When I Think of You," and the costume seen from the neck down was created in 1983 for "La Fantaisie en Plumes." The dancers pictured are, from left to right, Kirsten Citrone Frohlich, Amy Nicholson, Lazelle Howarth, Rebecca Gough DeLucca, Stephanie Jaynes, and Barbara May Kraemer. (Courtesy of UNLV Libraries Special Collections.)

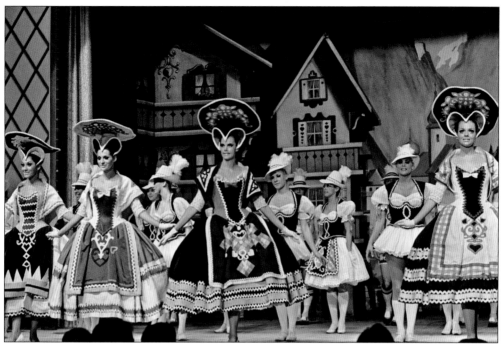

Michel Gyarmathy was an expert at conceiving mock historic scenes such as the one shown in this photograph from 1969. The costumes seen in "Mariage au Tyrol" are inspired by actual Tyrolean fashion, but Gyarmathy distorts the authentic to suit the sensual demands of cabaret theater. (Courtesy of Wolf Wergin/Las Vegas News Bureau.)

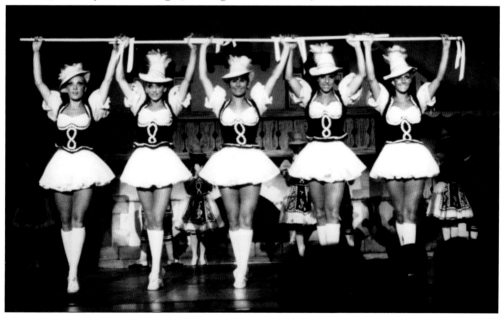

This photograph reveals the actual color of Gyarmathy's Tyrolean costumes as seen in the previous photograph. The acrobatic dancers pictured here onstage in the early 1970s are, from left to right, Karen Ribeiro, Cheryl Maclaren, Janice Kingham, Maxine Hillcoat, and Barbara Jago. (Courtesy of Maxine Hillcoat.)

This delightful costume was seen in the 1967 number "Les Lapins." The following year saw another animal costume number, "Les Pingouins de Paris." *Folies Bergere* creative director Jerry Jackson (1975–2009) affectionately describes these two Paris-designed scenes as bizarre yet charming French humor that likely did not translate as intended to the American audience. (Courtesy of Joe Buck/Milt Palmer/Las Vegas News Bureau.)

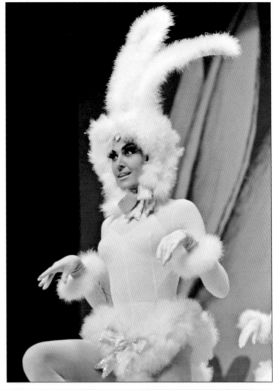

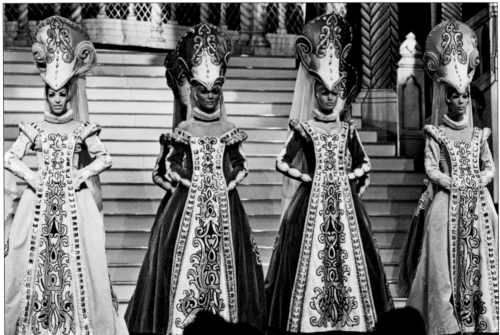

This photograph from 1968 features curious and unusually stoic cabaret costumes. Such stage costumes retain the essence of the referenced historic dress yet require accommodations to serve the physical requirements of the singers and dancers. (Courtesy of Milt Palmer/Las Vegas News Bureau.)

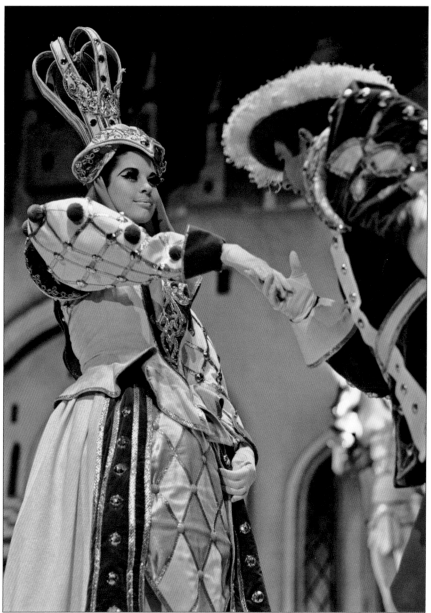

The "Centennial" edition was choreographed by Oscar and Emmy Award–winning Hermes Pan, who is most famous for his dance creations for the musical films of Fred Astaire and Ginger Rogers. Pan's work with the *Folies Bergere* is detailed in the book *Hermes Pan: the man who danced with Fred Astaire*: "Pan rehearsed 18 dancers and 16 showgirls for six weeks in a variety of lavish production numbers . . . Rehearsals generally began late in the morning with a break for dinner, followed by further rehearsal from 8:00 p.m. to around midnight." The assistant choreographer in 1966 was Jerry Jackson. This was Jackson's first association with the show and the beginning of a decades-long partnership for him and the *Folies Bergere*. This photograph from 1967 features a scene inspired by the board game chess and is an example of a tableau designed to appeal to the masculine tastes in the audience. The cast was brilliantly costumed as various game pieces in "Jeux d'Echecs." (Courtesy of Joe Buck/Milt Palmer/Las Vegas News Bureau.)

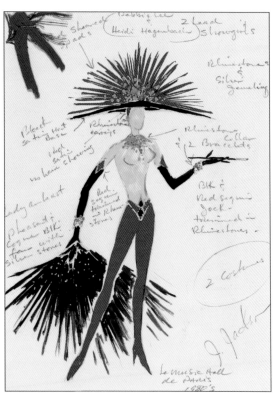

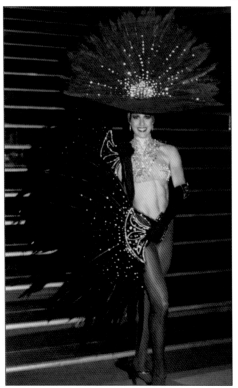

Costume designer Jerry Jackson earned his master's degree in art from the University of California, Los Angeles and boasts a professional background as a photographer and choreographer. This intriguing sketch for the number "Le Music Hall de Paris: 1980s" notes various details concerning the fabrication of the costume. Jackson includes rhinestone earrings, bracelets, and a collar in this design. A common element in cabaret costume design, rhinestones serve to enhance the overall impact of the costumes, choreography, and stage lighting. In describing the manufacturing process of the costumes seen in the 16th edition of the *Folies Bergere*, a press release notes, "A total of 72 elaborate necklaces are used just for the opening number. Only recently have Americans been able to manufacture their own quality costume jewelry that rivals that of Paris manufacturers." This rendering also indicates that these costumes were to be built for lead showgirls Debbie Lee and Heidi Hagenbach. In the photograph at left, Heidi Hagenbach Wallace is seen posing in the realized costume. (Both, courtesy of UNLV Libraries Special Collections.)

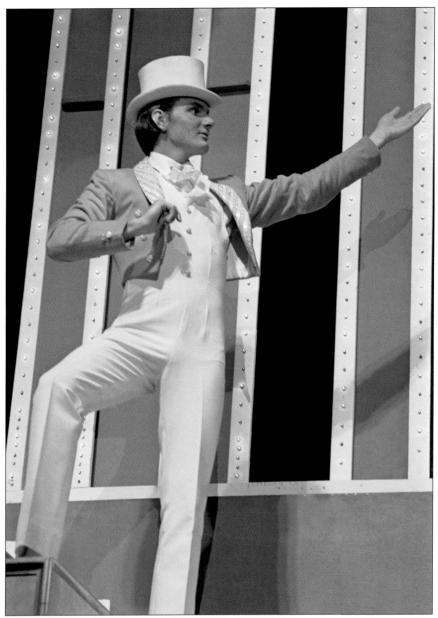

This photograph was taken in 1972 and features a suave showboy wearing a dapper male dance costume designed by Michel Gyarmathy. The pants and waistcoat of this costume are actually connected, forming a single garment. The jumpsuit maintains a clean, lean line during all types of choreography. Dancer Alan Clancy describes the role of a showboy in the cabaret genre, "One thing about being a man in the show, they wanted you to blend into the sets; we were there to support the women." In general, the mere physical existence of men onstage serves as a contrast that further emphasizes the splendor of the feminine form. Clancy goes on to describe the buzz of opening night at the *Folies Bergere*: "Elvis Presley and Liberace were in the audience . . . people would come to the openings in their furs and jewels . . . Everybody was glamourous . . . all the people that performed on the Strip would be there. They were always excited to see a new show." (Courtesy of John Cook/Las Vegas News Bureau.)

Three

LET'S HEAR IT FOR THE BOY
THE QUIET CONSEQUENCE
OF THE SHOWBOY

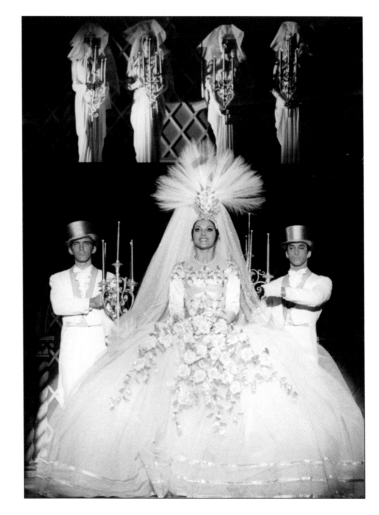

It is understandable yet unfortunate that the men do not get their due in the musical revue genre. Typically, the role of the male dancer is to focus audience attention on the presentation of the females. Here, the men frame the woman, directing the eye to the beauty and spectacle of the showgirl. Liliane Montevecchi is pictured as a fantasy bride in "Mariage en Blanc." (Photograph by Rob Gubbins.)

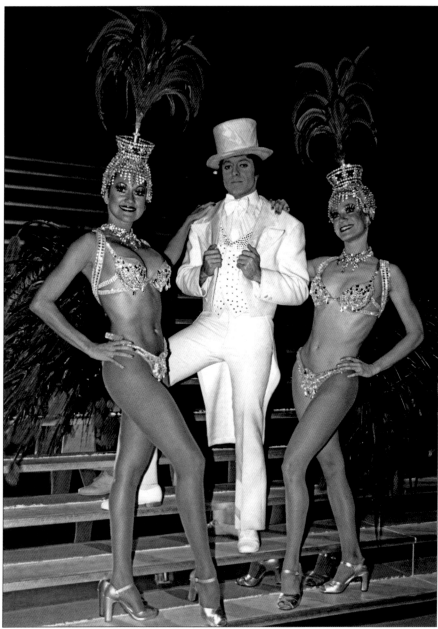

In this photograph, Rio Clehr Nole (left) and Linda James-Smith pose with Dave Post on the grand staircase wearing the classic showgirl ensemble: rhinestone and feather headdress, rhinestone neck piece, diamante brassiere and thong panty, feather backpack, fishnet tights, open-toe dance shoes, and lavish false eyelashes. Cabaret performers are expert at navigating the stage with the added impairment of varied and cumbersome costume pieces. The costumes seen in this photograph were designed by Nolan Miller for the first American-produced edition of *Folies Bergere* in 1975. The development of this 15th edition of the show was valued at $5 million by the Hotel Tropicana. The show's famous set piece, the grand staircase, was constructed in 1975 and used continually until the close of the show in 2009. Its employ served to provide audience members seated in any section of the theater with a favorable view of the scene at hand. (Courtesy of Rio Clehr Nole.)

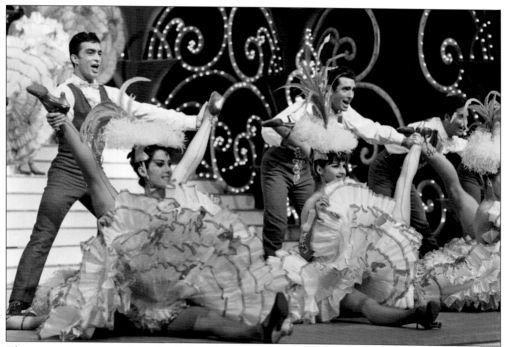

The energetic can-can dance hails from 19th-century Europe and features kick lines, cartwheels, and jump splits. Explicit flaunting of undergarments, coupled with suggestive bodily contact between the male and female dancers, proved to be a challenge to the conventions of the era, and, not surprisingly, the risqué sexual innuendo provoked a scandalous reputation for the dance. (Courtesy of Don English/Joe Buck/John Cook/Las Vegas News Bureau.)

Both photographs on this page were taken during the 1963 edition of the *Folies Bergere*. This photograph features dancer Vassili Sulich during the execution of a breathtaking can-can number lift. Sulich performed as a principal dancer in show for nine years. He is also credited with founding the Nevada Ballet Theatre. (Courtesy of Don English/Joe Buck/John Cook/Las Vegas News Bureau.)

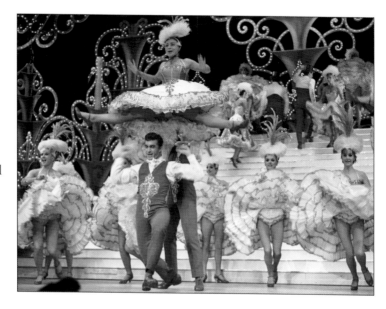

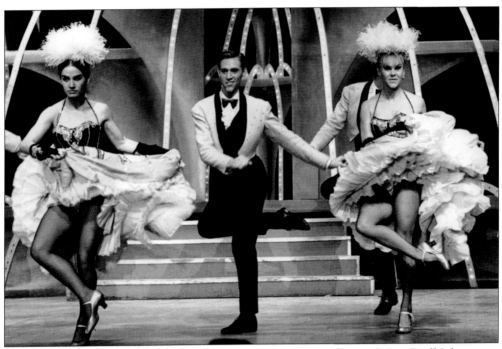

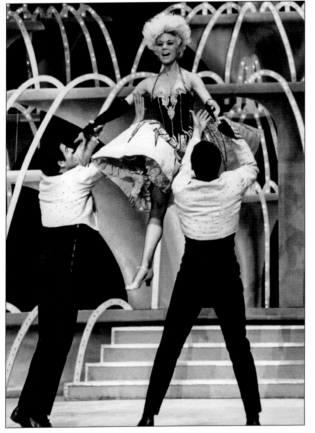

Performer DeLee Droll Johnson, cast in 1969 at just 18 years old, notes the irony found in her situation, wherein she was presumed too young to watch the show yet definitely not too young to perform in it. Costumed in a rhinestone-studded tuxedo, the charismatic showboy in this photograph is pictured performing in a *Folies Bergere* can-can number during the 1960s. (Photograph by Rob Gubbins.)

"The rehearsals were pretty grueling, up all night. They'd call you in [to rehearse] whenever they wanted," explains *Folies Bergere* acrobatic dancer Alan Clancy. This 1960s photograph was captured during a lively lift segment in the choreography for the number "Le French Can-can." (Courtesy of Don English/ Las Vegas News Bureau.)

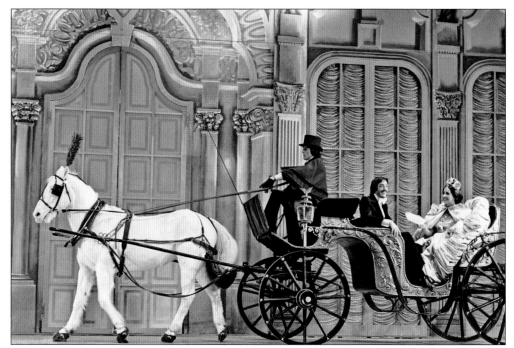

A horse-drawn carriage was driven across the stage in "La Grande Maniere: Vienna, 1850." Alumni Rio Clehr Nole and Patrick Nole reveal that, occasionally, Frosty, the horse, would have an onstage "accident." These incidents were particularly annoying to the acrobats whose back flips and jump splits required bodily contact with the stage floor. In this 1975 photograph, principals Buddy Vest (left) and Maggie White (right) ride in the carriage driven by Dave Post. (Courtesy of Lee McDonald/Las Vegas News Bureau.)

In this backstage shot, Buddy Vest (left) and Maryann Hernandez Picchi (right) pose for the camera in their "Jazz: 1920" costumes. Vest is credited as "Le Song and Dance Man" in the number and as "Master of Ceremonies" in the first American-produced edition of the *Folies Bergere*. (Courtesy of Maryann Hernandez Picchi.)

The production's frequent return to an 18th-century French court theme afforded the male dancers an opportunity to don some pretty fancy character costumes. In this tableau from 1963, both dancers are costumed for a ball at the Palace of Versailles during the reign of Louis XIV in the scene titled "Reception à Versailles." (Courtesy of Don English/Joe Buck/ John Cook/Las Vegas News Bureau.)

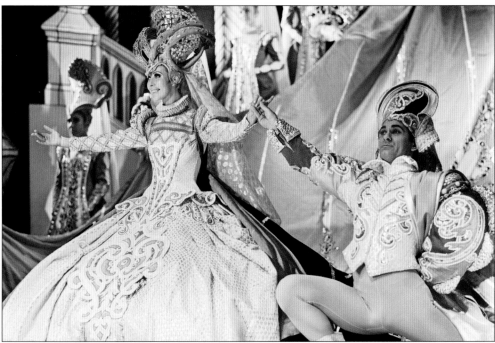

In this photograph from 1967, male principal dancer Vassily Sulich (right) is seen dressed in the splendor of a historical costume. The showgirl's costume unfurls for many feet behind her and extends up the length of the staircase, making for a grand and magnificent entrance. (Courtesy of Joe Buck/Milt Palmer/Las Vegas News Bureau.)

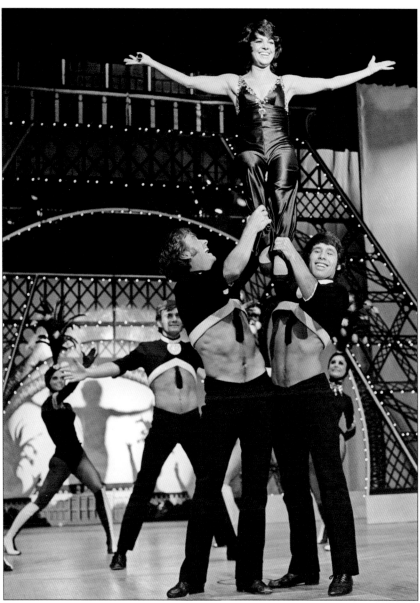

Making her American debut, French singer and dancer Audrey Arno received top billing in the 1972 edition of the *Folies Bergere*. Arno was the first entertainer to earn "star" status in the Las Vegas production. This photograph shows a thrilling lift sequence from the number "Ca C'est Paris" and features the "petite Parisienne" elevated by a few good men. This number is remembered as a stylistic departure for the *Folies Bergere*. Dancer Alan Clancy identifies it as one of his favorites and describes the choreography as "jazzy." The unadorned yet striking contemporary costumes are indeed a deviation from designer Michel Gyarmathy's typical "more is more" approach. The playful and considerable tassel seen at center front on the men's costumes was ultimately removed because it interfered with the dance routine. The stage decoration in this act featured a replica of Paris's historic Eiffel Tower. The number derived its name from a song popularized in 1926 by famous French musical revue star Mistinguett. "Ca C'est Paris" translates to "That's Paris." (Courtesy of John Cook/Las Vegas News Bureau.)

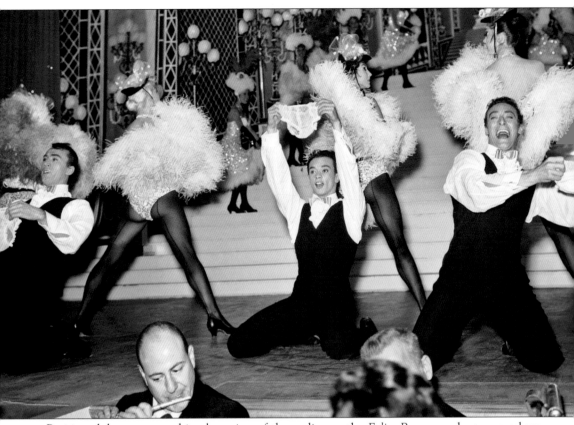

Positioned downstage and in clear view of the audience, the *Folies Bergere* orchestra members were a vital part of the show. Many alumni recall spontaneous and amusing interactions between dancers and musicians during the energetic live performances. Acrobatic dancer DeLee Droll Johnson recalls one such incident: "My flying split landed right in front of Si Zentner [orchestra conductor]. I had to hold it [split position] until the last girl finished her [flying split] and Si would try to unbuckle my shoe. I fought him off for several shows but he persevered until he finally got his way. I held it [the shoe] on with my toes curled for the remainder of the dance but it eventually went flying off into the audience during the bend back kicks. He got in trouble for that so it finally stopped." (Courtesy of Las Vegas News Bureau.)

In the summer of 1989, as the musician union's contract negotiations were deteriorating, the 13 *Folies Bergere* orchestra members elected to strike the Hotel Tropicana, thus forcing the production to go dark. Three weeks into the walkout, the show reopened to taped musical accompaniment and never returned to the heyday of a live onstage orchestra. (Courtesy of John Cook/Don English/ Joe Buck/Las Vegas News Bureau.)

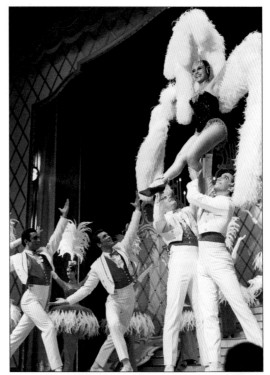

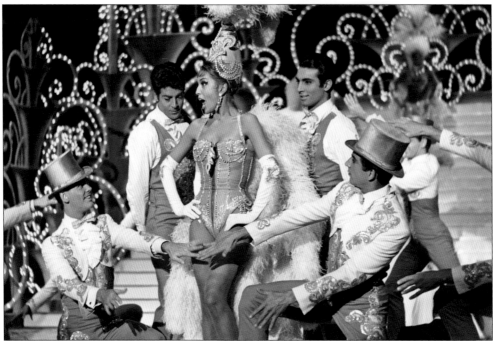

In both photographs on this page, Liliane Montevecchi is pictured surrounded by the men of the *Folies Bergere*. This image shows a scene from the 1963 edition of the show wherein the male dancers quite literally serve to direct the eyes of the audience to the featured female. (Courtesy of Don English/Las Vegas News Bureau.)

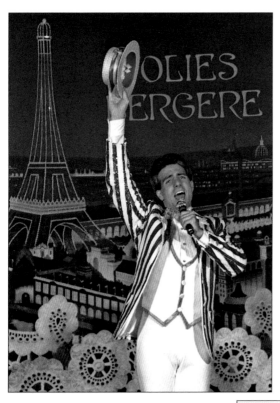

The male performers of the *Folies Bergere* were frequently costumed in classic and elegant tailcoats and tuxedos. "I wanted the men to look like men," explains costume designer Jerry Jackson. This photograph of singer J.P. Macchiaverna in the number "Le Music Hall de Paris: 1900s" appeared in a souvenir booklet promoting the 1983 edition of the show. (Courtesy of Nevada State Museum, Las Vegas.)

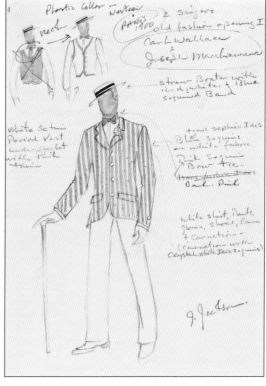

This type of costume rendering is called a "working sketch." Designer Jerry Jackson quickly puts his ideas to paper, communicating details and revisions concerning the production of the costume. The working sketch is very useful for the technicians responsible for manufacturing the costume. This drawing depicts the costume seen in the previous photograph. (Courtesy of UNLV Libraries Special Collections.)

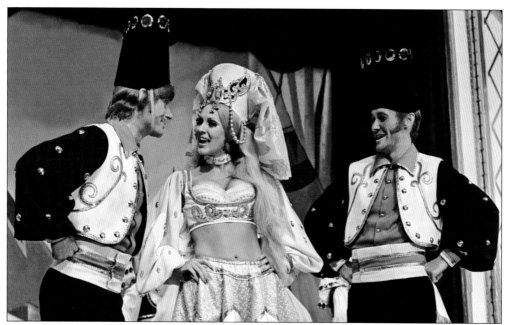

In another of the production's historical romps through time, the "Never Before" edition of the *Folies Bergere* presented a scene based on the adventures of Casanova and interpreted the traditional dress of the gypsy. This photograph features Carolynn Everette (center) in the 1972 number titled "Casanova." (Courtesy of John Cook/Las Vegas News Bureau.)

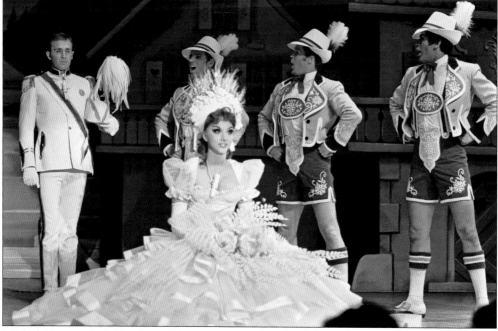

Michel Gyarmathy's Tyrolean folk costumes and set backdrops for "Marriage au Tyrol" were charming and convincing adaptations of the traditional. Showgirl Fabiola is pictured in 1969 and costumed as the Tyrolean bride; at left is singer Bill De Bell. (Courtesy of John Cook/Las Vegas News Bureau.)

The entr'actes of the cabaret genre provide essential breaks between the production numbers so that the main cast has time for costume changes and the crew has a chance to swap and rearrange set pieces. This photograph from the 1960s captures the formidable juggler Francis Brunn performing on the *Folies Bergere* stage. (Photograph by Rob Gubbins.)

This photograph was taken on March 10, 1970, during a special performance on the *Folies Bergere* stage by entertainer Ted Lewis. This one-night-only event honored the master showman for his contribution to musical revue theater. Lewis's legendary act incorporated song, dance, comedy, and an abundance of personality. The vintage vaudevillian, sporting his trusty crumpled silk top hat and clarinet, is pictured with Tamara Christina Heyer (left) and Twila Saylor. (Courtesy of Tamara Enigi-Deaton.)

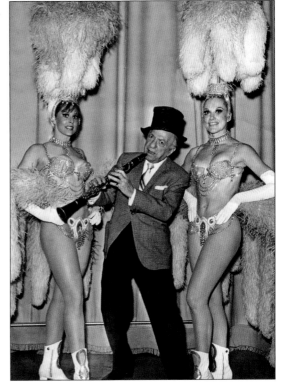

Somehow, the brilliant Bob Williams developed a successful comedic animal act that celebrated his dog Louie's apparent lack of talent. Although Louie was in fact highly trained, the joke was that Louie was unable to properly execute even the simplest dog trick. Williams and "You Can Do It Louie" elevated doing "absolutely nothing" to an art form. This photograph was taken in 1968. (Courtesy of John Cook/Las Vegas News Bureau.)

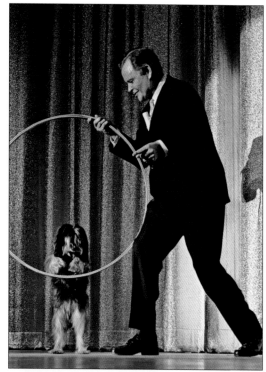

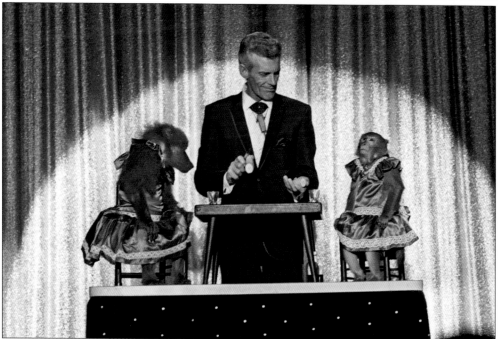

Gus Augspurg and His Girlfriends was a popular animal act in the *Folies Bergere*. Augspurg's "girlfriends" were two highly trained and well-dressed baboons. Acrobat dancer Lori Casler Rich remembers, "Mary Jane was the nice monkey and Judy was the evil one." This photograph of the famous trio was taken in 1969. (Courtesy of Robert Scott Hooper/Las Vegas News Bureau.)

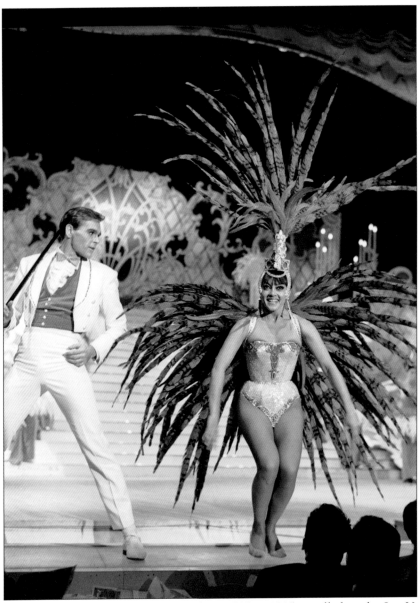

Don Martinez, *Folies Bergere* stage manager from 1982 to 1995, recalled to the *Las Vegas Sun* newspaper, "They say you weren't a showgirl until you fell down the stairs. That was the most dangerous thing in the show. The lead singer, in the opening number, comes down these big gold stairs, singing. Her costume was a big feather piece, with feathers trailing behind her. She tripped at the top and rolled down stairs, doing somersaults, her feathers flying. She kept singing, but you could only hear every third word, 'cause her arms were flying around. She looked like a peacock hit by a car." Charles Castle describes the business of building the show's ornate costumes in his book *The Folies Bergere*: "To sequin a costume [all done by hand], more than eleven days' work is put into the garment by two pailleteuses, and to make a costume adorned with feathers requires the industry of about four dressmakers involving 200 hours of work." Here, Liliane Montevecchi flaunts her costume's large feather backpack and headdress. (Courtesy of John Cook/Don English/Joe Buck/Las Vegas News Bureau.)

Four

THE CABARET COCKTAIL

AN ELABORATE CONCOCTION OF SEDUCTION, FANTASY, AND SPECTACLE

Within the cabaret canon is a touch of the risqué, a hint of the exotic, a surplus of glamour, and a deficit of narrative. Invading the stage for the opening number in a riot of texture and sparkle, the showgirls and showboys pictured here in 1972 are, from left to right, Alan Clancy, unidentified, Carolynn Everette (center), Yvonne Brown Allen, unidentified, and Don Correia. (Courtesy of John Cook/Las Vegas News Bureau.)

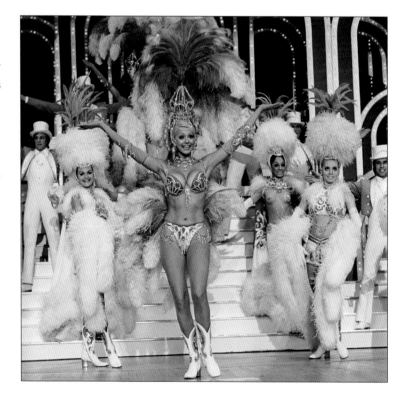

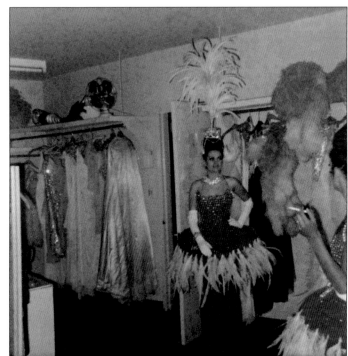

A behind-the-scenes glimpse into a showgirl's dressing room is always fascinating. This color snapshot shows showgirl Lisa Malouf Medford dressed in costume for the number seen in the next photograph. Medford danced with the *Folies Bergere* from 1959 to 1968. Note that the other performer pictured is smoking. Cigarette smoking was allowed in the dressing rooms until the early 1980s. (Courtesy of Lisa Malouf Medford.)

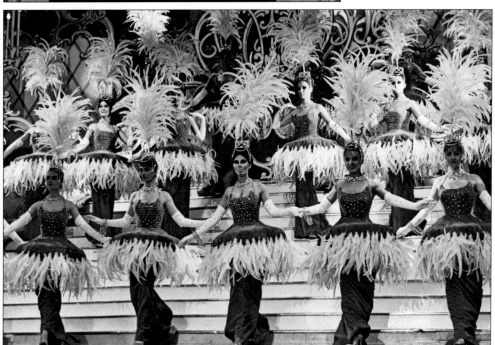

Dealing with the show's grand staircase was no easy feat for the performers. Choreography involving stairs was complicated by cumbersome stage costumes. Lisa Malouf Medford recalls a scary moment while wearing this costume. During one performance, a dancer in front of her suddenly tripped and slipped down the stairs, breaking her arm. Malouf faults the "sausage skirt" for this battlefield accident. (Courtesy of John Cook/Don English/Joe Buck/Las Vegas News Bureau.)

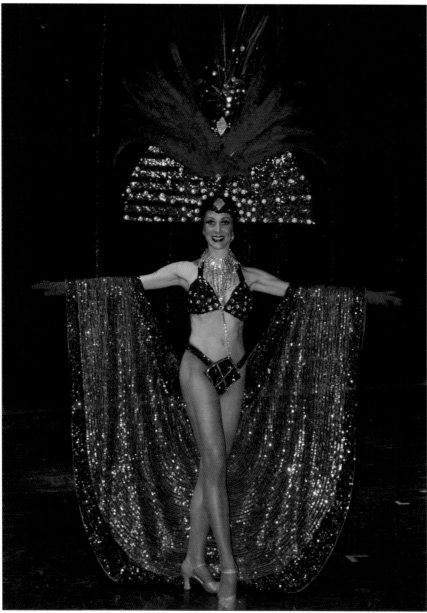

Angela Santangelo, featured here, performed in the *Folies Bergere* as both a dancer and a showgirl during her term with the production. Showgirls are sometimes described as "mannequins" and often play a role that differs from the "nude dancer" position (female dancers who perform topless). Santangelo explains the typical variations in responsibility: "Showgirls would 'dress' the set. Their costumes were grander and the steps easier." The spectacular costume seen in this photograph was designed by Jerry Jackson for the 16th edition of the *Folies Bergere*. Jackson revealed that if he had the opportunity to redo one of his costumes, he would likely select this large sequined cape to redesign. He explains that, when completed, this solid sequined costume piece weighed in at much more than anticipated. As pictured here, the dancers wore the cape with arms outstretched. Jackson still remembers the dire complaints from performers with exhausted arm muscles. (Courtesy of Angela Santangelo.)

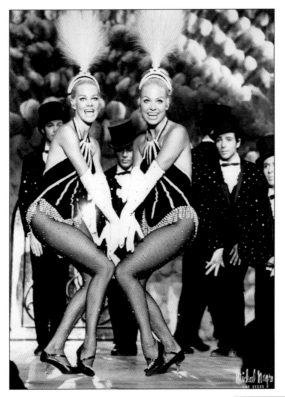

The *Baker Twins* and the *Bel-Air Sisters* were both twin acts that performed on the *Folies Bergere* stage. The charming *Bel-Air Sisters* are pictured here in the number "Arc en Ciel de Paris" during the late 1960s. The *Dodge Twins* were another duo who famously sang and danced with the Parisian *Folies Bergere* during the Jazz Age. (Photograph by Rob Gubbins.)

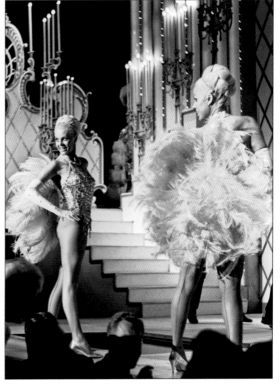

In this image, made in 1967, the *Bel-Air Sisters* show off their fantastic matching feather bustles. The twins also wear seamed fishnet-style pantyhose. Perfectly exemplifying the allure of intermittent veiling and unveiling of skin, fishnet stockings are a staple of the cabaret costume. (Courtesy of Joe Buck/Milt Palmer/Las Vegas News Bureau.)

Identical twin sisters Teri Bartlett Thorndike (left) and Sheri Bartlett Mirault (right) were each cast, separately, in 1970. Teri Bartlett Thorndike was first to travel to Las Vegas from Texas to audition for the *Folies Bergere*. After winning a position in the cast, the show's producers, not realizing that Thorndike was a twin, jokingly asked her, "Do you have a sister?" (Courtesy of Las Vegas News Bureau.)

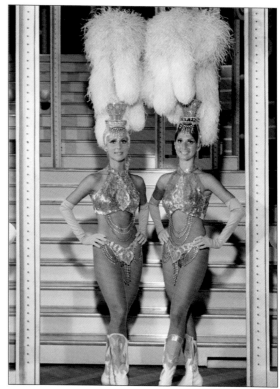

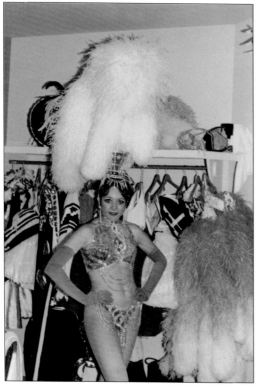

In this dressing-room photograph dated January 1969, Lori Casler Rich reveals the actual color of the twins' costumes from the previous photograph. *New York Post* critic Nadle Sillenak described the 1969 edition of the *Folies Bergere* as "Splendiferous." (Courtesy of Lori Casler Rich.)

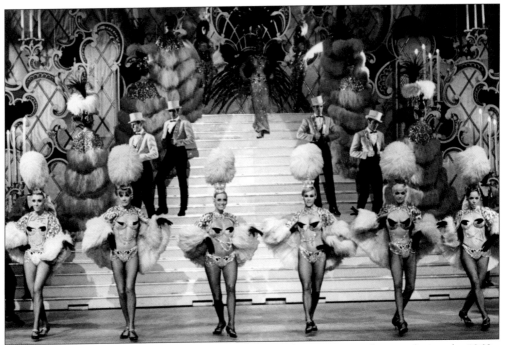

Michael Nagro was the in-house photographer for the *Folies Bergere* production during the 1960s. Photographs taken during the show would be processed and ready for purchase following the final curtain. This photograph was taken by Rob Gubbins during his employ with Michael Nagro Photography. (Photograph by Rob Gubbins.)

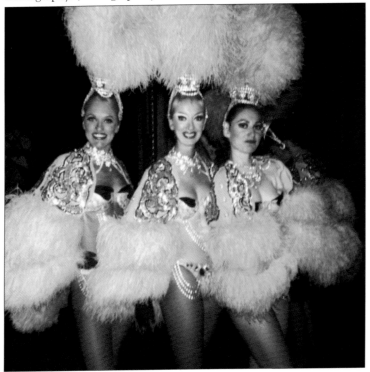

This is a rare amateur photograph taken backstage at the *Folies Bergere*. Acrobat dancer Shirley Lewis Stegall explains that during the 1960s, one of the only ways for performers to obtain pictures for personal use was "to sneak cameras backstage." This behind-the-scenes snapshot reveals the actual color of the costumes featured on stage in the previous photograph. (Courtesy of Rio Clehr Nole.)

Shirley Lewis Stegall (left) and Maxine Hillcoat (right) are pictured in this snapshot from March 1969. These ladies were members of the Rudas Acro-Dancers troupe. This group performed with the *Folies Bergere* and was renowned for their precision acrobatic routines. As evidenced in the next photograph, by 1970 the boots and gloves that coordinate with this pink costume, originally designed in black, had been revised to white. (Courtesy of Maxine Hillcoat.)

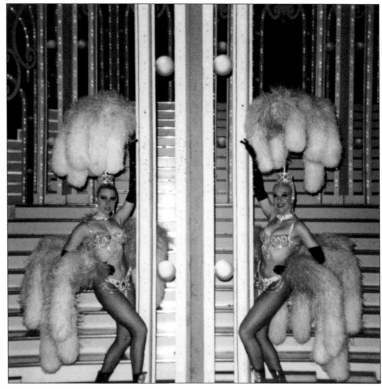

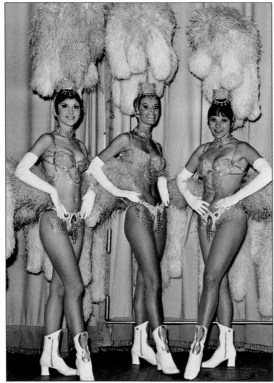

Performers Jeanne Marsh Rozzi (left), Christine Chapman, and Lori Casler Rich (right) pose onstage in 1970 wearing costumes designed by Michel Gyarmathy. Maurice Chevalier, the acclaimed French actor, comic, and cabaret singer, described Gyarmathy as "an artist whose imagination and inventiveness, both in writing and design, would appear to be inexhaustible." (Courtesy of Joe Buck/Las Vegas News Bureau.)

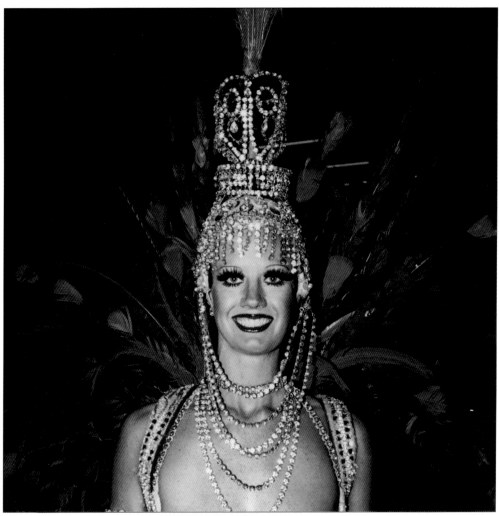

Joseph V. Agosto, affiliate of the Kansas City mob syndicate, was credited as the executive producer of the *Folies Bergere* during the late 1970s. "He became the executive producer," explains Mob Museum director of content Geoff Schumacher, "not because he had a great deal of expertise with production shows, but because there was no chance he was going to get a gaming license to run the Tropicana." Agosto's producer gig was a precondition of the mob's financial loan to the Tropicana Hotel and served as an open door for Agosto to set up shop inside the casino. The resulting cash "skim" was exposed and dissolved by the Federal Bureau of Investigation in early 1979. Pictured is showgirl Maryann Hernandez Picchi. She recalls that, "It was generally understood among the cast that Agosto and his associates were representing the mob's interests in the show." Picchi notes that insofar as their paychecks cleared, the cast and crew were not overly concerned about who it was that was signing them. (Courtesy of Maryann Hernandez Picchi.)

This gorgeous image from 1975 features showgirl Maggie White and a vintage Rolls Royce automobile that served as a stage prop and set piece in the 1975 edition of the *Folies Bergere*. The distinguished Rolls Royce was driven onstage and used during the scene "Nostalgie: Harlem 1930." (Courtesy of UNLV Libraries Special Collections.)

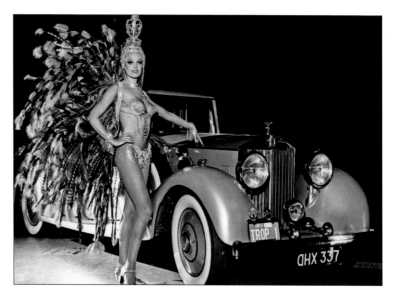

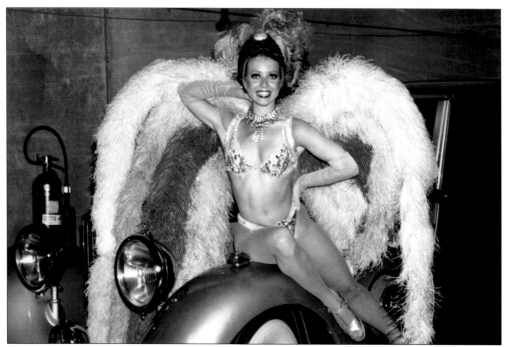

In this photograph from 1979, acrobat dancer Kim Kephart-Grandusky strikes a pose backstage and atop the show's classic Rolls Royce car. Kephart-Grandusky is pictured wearing her costume for "La Grande Finale." Large costume pieces, such as this feather backpack, were usually stored overhead in the theater's fly system until needed. Wardrobe department "dressers" helped the performers don the backpacks just before their stage entrance. (Courtesy of Kim Kephart-Grandusky.)

A critic's review of the can-can number from the 15th edition of the show commends creative director Jerry Jackson's talents: "The Can-can shows all the dancers . . . at their best. Not only is it well performed, it is beautifully staged. Indeed, staging appears to be Jerry's forte throughout the show." This illustration was inspired by poster art advertising 19th-century French music hall shows. (Courtesy of Nevada State Museum, Las Vegas.)

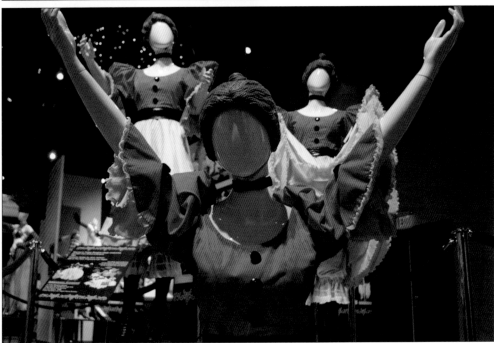

An extraordinary attribute of the *Folies Bergere* archive at the Nevada State Museum, Las Vegas, is the inclusion of multiple copies of the same costume. Multiples afford the museum an opportunity to exhibit the costumes as they were originally designed for use on the stage. This photograph features the museum's 2016 exhibition "Les Folies Bergere: Entertaining Las Vegas, One Rhinestone at a Time." (Author's collection/Nevada State Museum, Las Vegas.)

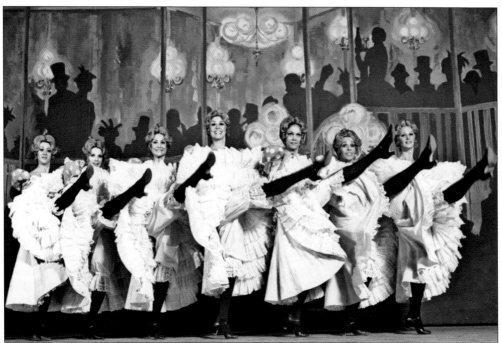

The backdrop art seen behind the can-can dancers in this photograph is inspired by the paintings of French artist Henri de Toulouse-Lautrec. Toulouse-Lautrec created many iconic images of Parisian nightlife and can-can dancers during the late 19th century. The *Folies Bergere*'s award-winning can-can number was routinely cited as a highlight of the Las Vegas production. (Courtesy of Lee McDonald/Las Vegas News Bureau.)

Nolan Miller designed costumes for the production from 1975 through 1980. Miller earned a primetime Emmy Award for Outstanding Costume Design on the 1980s mega-hit television series *Dynasty*. Jerry Jackson, *Folies Bergere* creative director explains, "We would've kept Miller on as costume designer but Aaron Spelling [*Dynasty* producer] insisted that Miller sign an exclusive agreement to work only for Aaron Spelling Productions." (Courtesy of UNLV Libraries Special Collections.)

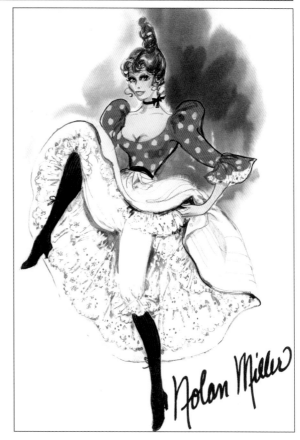

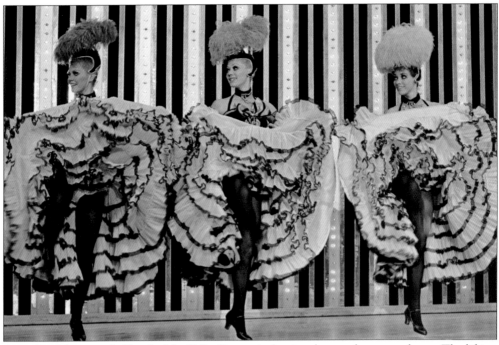

A staple of the music hall and of the *Folies Bergere* is the time-honored can-can dance. The lifting and boisterous manipulation of the ruffled petticoat skirts are established movements of the dance. The color snapshot below shows one version of the variegated "Le Can-Can" costumes seen in this 1972 photograph. (Courtesy of John Cook/Las Vegas News Bureau.)

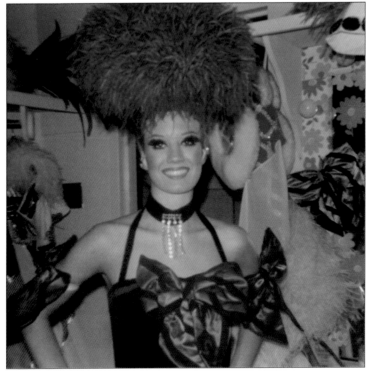

Acrobat Randy Wycoff recalls that musical conductor Si Zentner "liked to speed up and then slow down the can-can number. Up and down, up and down, and always with a big grin on his face. . . . The number was hard enough without his games. Looking back now, it was pretty funny." Here, Maryann Hernandez Picchi is dressed for the can-can scene in the early 1970s. (Courtesy of Maryann Hernandez Picchi.)

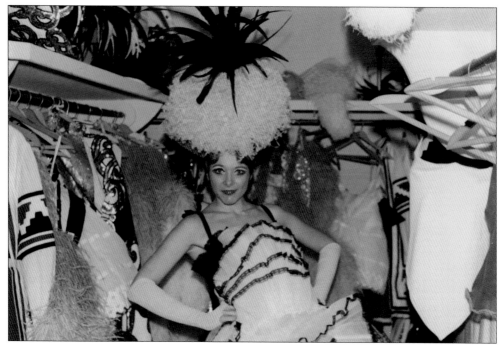

Every edition of the *Folies Bergere* included a scene featuring the can-can dance. Typically, the entire cast, or "toute la compagnie," was included in these high-energy and raucous routines. Acrobat dancer Lori Casler Rich is pictured in her dressing room costumed for a late-1960s version of the can-can number. (Courtesy of Lori Casler Rich.)

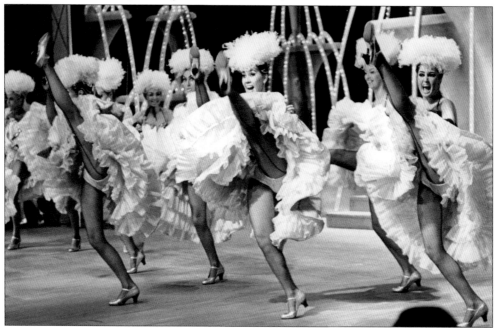

The well-known can-can song is a piece of music written for an 1858 operetta by European composer Jacques Offenbach. This stage photograph from the 1960s shows the *Folies Bergere* dancers executing the traditional high kick of the can-can dance. (Photograph by Rob Gubbins.)

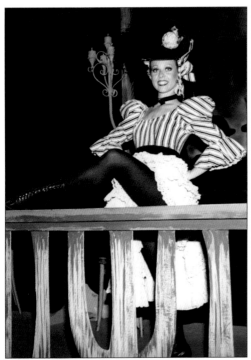

In this photograph, acrobat Kim Kephart-Grandusky is costumed for "Le Can-can: France 1900." She recalls the burdensome weight of the numerous gathered and layered rows of cotton that made up the costume's substantial petticoat. As the role of the performer is to suspend reality, the audience would have no insight into the challenges of executing cartwheels, back bends, and jump splits while wearing a garment of this scale. (Courtesy of Kim Kephart-Grandusky.)

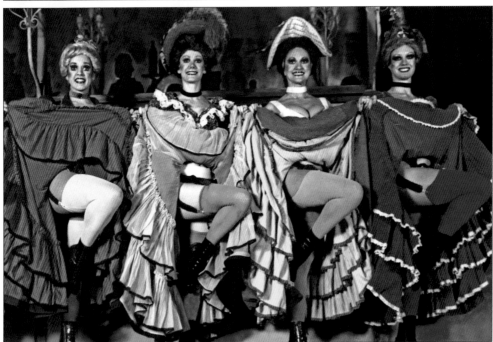

Leslie Cook, Linda James-Smith, Rio Clehr Nole, and Maryann Hernandez Picchi are pictured wearing Nolan Miller's adaptation of the can-can costume. Of note is the addition of colorful stockings and garters. During the late 19th century, this view of the upper leg, between the top of the stocking and the panty, was judged by the "respectable" Victorian public as a shocking and scandalous display. (Courtesy of Rio Clehr Nole.)

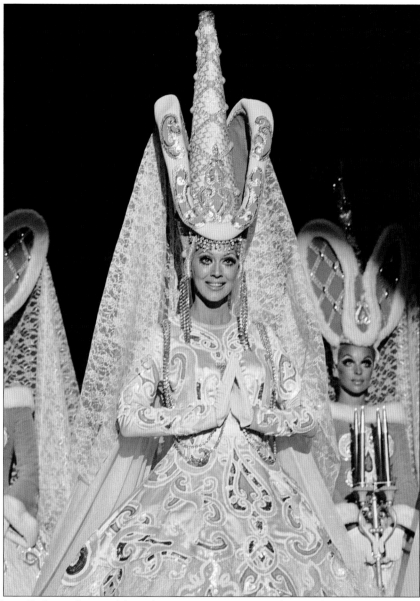

The "Never Before" edition of the *Folies Bergere* in 1972 was advertised as costing "more than one million dollars with almost all of the costumes and scenery being imported from France. Feathers from 25,000 South African birds and costumes costing as much as $5,000 a piece are used in the show. The cast and crew number more than 150." This image was taken in 1972 during the scene titled "Cathedrale" and features principal performer Carolynn Everette (center) wearing a magnificent Gothic character costume designed by Michel Gyarmathy. Set pieces inspired by the stained-glass window designs of French cathedrals completed this fantasy set in the middle ages. The scene cleverly injected a note of piety into an otherwise sensual presentation. Such witty absurdities are inherent to the spirit of the musical revue. Gyarmathy describes the foundational template for every edition of the *Folies Bergere* as "Always a cocktail: something sweet, something sour, something strong, and something effervescent." (Courtesy of John Cook/ Las Vegas News Bureau.)

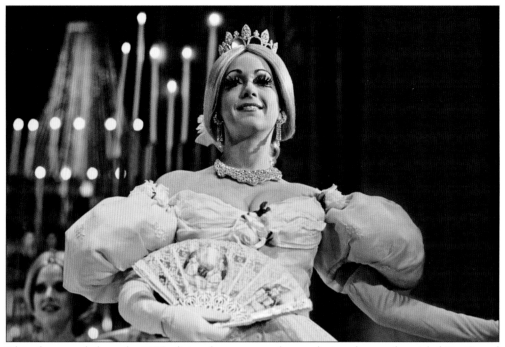

This photograph from the 1975 edition features a performer during the number titled "Le Grand Maniére: Vienna 1850." Nicknamed the "ballroom," the scene imagined a mid-19th-century evening filled with the music of the Viennese Waltz. The female performers were costumed in elegant satin gowns complete with full hooped skirts. (Courtesy of Lee McDonald/Las Vegas News Bureau.)

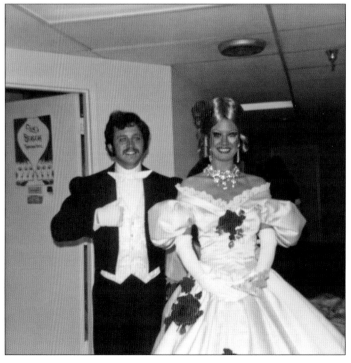

In musical revue theatre, scenes such as "Le Grand Maniére: Vienna 1850" are designed to communicate a caricature of the look and feel of the period rather than a historically accurate representation of the age. This backstage snapshot features Ron Clemmer (left) and Maryann Hernandez Picchi dressed in costume for the "ballroom" number. (Courtesy of Maryann Hernandez Picchi.)

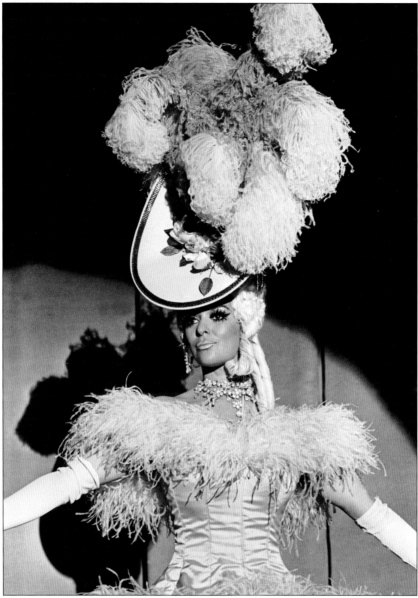

This photograph from 1972 features a historically inspired costume seen in the show's return to the Palace of Versailles in 18th-century France. The headdress includes a hairpiece. Typically, a wig component is combined with and connected to the headdress to create a single unit. This arrangement serves to facilitate quick costume changes. Another component included in the showgirl archetype is false eyelashes. This essential accessory serves to define, highlight, and animate eyes that would otherwise appear vague from the perspective of the audience. Whether spiky, shaggy, feathery, or fluffy, false eyelashes effectively thwart the fading effects of bright spotlights. At times layered in triplicate, they proved weighty, hindered vision, and had a tendency to graze the cheek during each blink of the eye. *Folies Bergere* dancer Rio Clehr Nole explains that her false eyelashes were handmade. Nole cut her eyelashes out of black construction paper and then curled the fringed paper cutouts onto a pencil to shape and set. (Courtesy of Gary Angell/ Las Vegas News Bureau.)

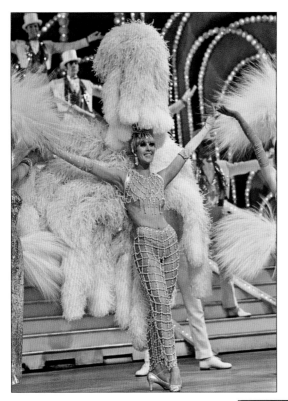

This showgirl is pictured in 1968 during the production's finale number titled "Lumières de Paris." The *Las Vegas Sun* newspaper describes the 1968 edition of the *Folies Bergere* as a "dazzler" and "a contrived pastiche of richly costumed men and women." (Courtesy of John Cook/Las Vegas News Bureau.)

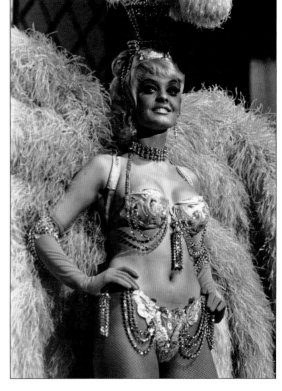

Both showgirls pictured on this page wear a typical costume piece of the cabaret genre known as a "backpack" or "halter." This garment further decorates the showgirl, frames the female form, and amplifies the overall scale of the showgirl's stage silhouette. This photograph was taken in 1969 during the ninth edition of the *Folies Bergere*. (Courtesy Joe Buck/Las Vegas News Bureau.)

This adorable performer appeared on the *Folies Bergere* stage in 1963. Advertisements for this edition announced, "See the most ravishing girls in the world! See the show that's like no other show on earth—the pride of Paris, the talk of Las Vegas!" (Courtesy of Don English/Las Vegas News Bureau.)

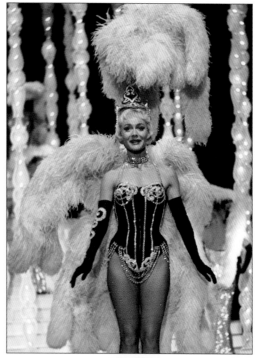

Showgirls act the part of seductress by tempting the audience with charm and mystery. Svetlana Failla, who danced with the *Folies Bergere* for 10 years, reveals, "When I go onstage I disappear. I always pick someone in the audience and perform for them." In this photograph from the early 2000s, showgirl Janu Tornell-Ferraro wears a substantial feather backpack. (Courtesy of UNLV Libraries Special Collections.)

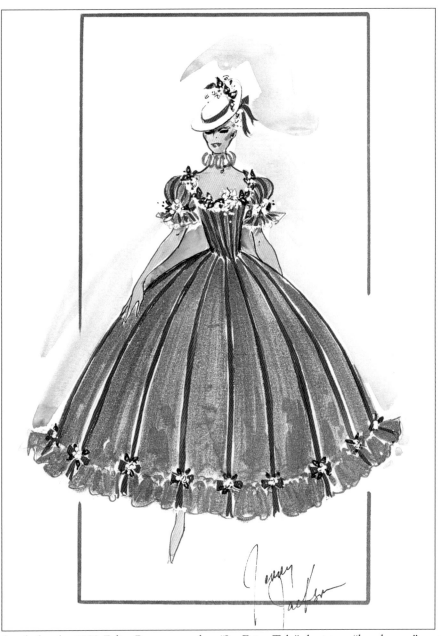

This sketch for the 1983 *Folies Bergere* number "Le Fairy Tale" depicts a "breakaway" costume constructed to be easily removed onstage and in clear view of the audience. The costume was created for a featured performer known as an adagio dancer. Typically, the adagio segment is a slow, graceful duet emphasizing technical dance skill. The *Folies Bergere* cast includes showgirls, nude dancers, dressed dancers, adagio teams, acrobats, and singers. Each of these groups has unique choreography and roles to play within the structure of the show. The show's costume designer is responsible for creating separate yet related costumes for each of the dance lines. Costumes communicate the theme and narrative of the scene and take into account the specific demands of the choreography. Successful costumes serve and enhance the work of the performer. (Courtesy of UNLV Libraries Special Collections.)

Costume designer Jerry Jackson developed 110 separate costumes for the 16th edition of the production. The rendering shown here is a design for "Le Fairy Tale" and is described in promotional materials as "a traditional French fairy tale, featuring lavish storybook costumes and scenery, a magnificent adagio dance, and a surprise ending!" (Courtesy of UNLV Libraries Special Collections.)

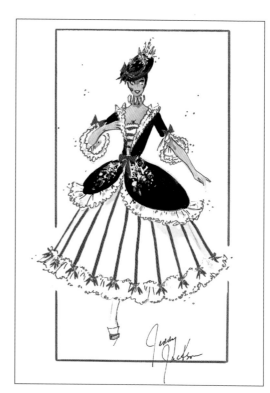

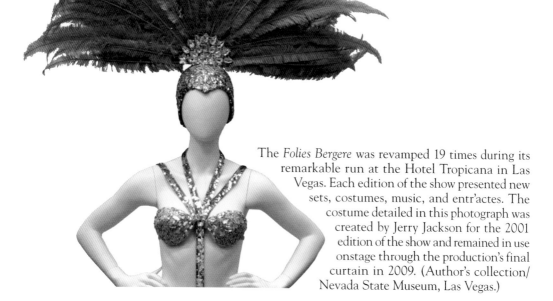

The *Folies Bergere* was revamped 19 times during its remarkable run at the Hotel Tropicana in Las Vegas. Each edition of the show presented new sets, costumes, music, and entr'actes. The costume detailed in this photograph was created by Jerry Jackson for the 2001 edition of the show and remained in use onstage through the production's final curtain in 2009. (Author's collection/ Nevada State Museum, Las Vegas.)

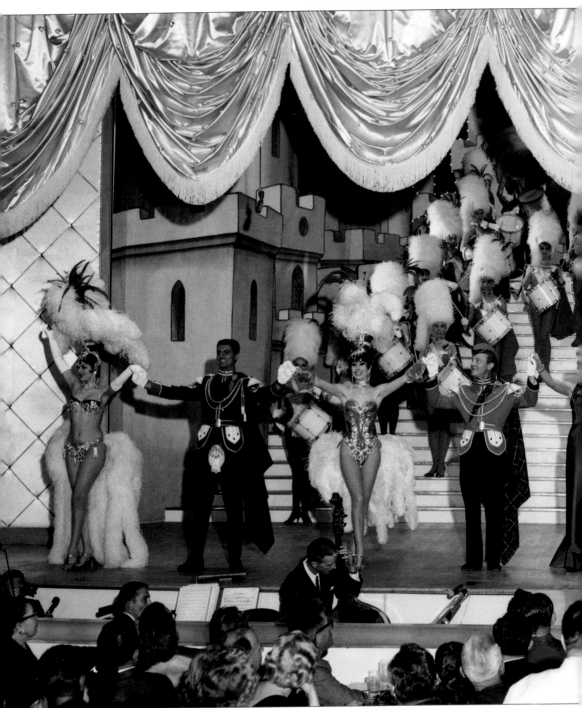

Describing his affection for the show in 1959, *Las Vegas Sun* editor Hank Greenspun writes, "*Folies Bergere* transplants you to another world. A lovely continental atmosphere that moves so fast the audience doesn't realize it's over until they spontaneously come to their feet to salute the most artistic of acts." Nearly 50 years later, Greenspun's son Brian Greenspun published his own sentiments concerning the looming closure of the musical revue: "Thank you *Folies Bergere* and

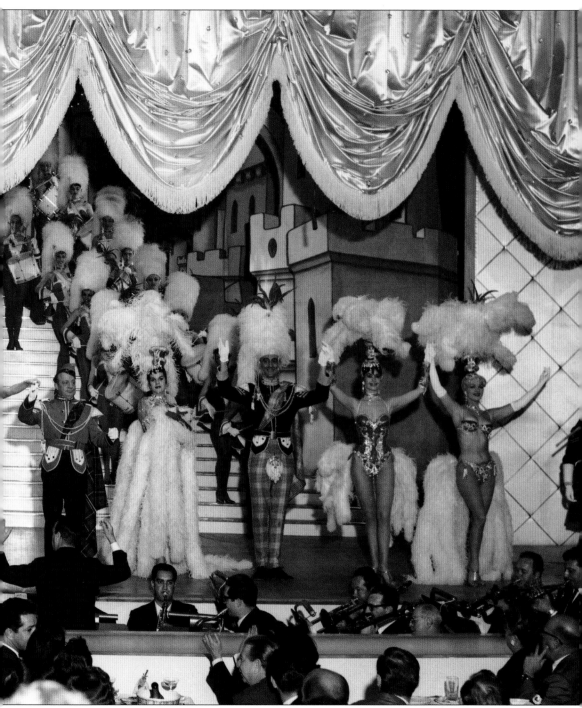

thank you [Hotel] Tropicana for a marvelous and entertaining half century—the kind that can only be found in Las Vegas." Showgirl and dancer Angela Santangelo reminisces about her tenure with the legendary production: "It was the time of my life to be in that show." This photograph captures the Venetian-style curtain coming down on the Fountain Theatre stage during the 1961 edition of the *Folies Bergere*. (Courtesy of Don English/Las Vegas News Bureau.)

DISCOVER THOUSANDS OF LOCAL HISTORY BOOKS FEATURING MILLIONS OF VINTAGE IMAGES

Arcadia Publishing, the leading local history publisher in the United States, is committed to making history accessible and meaningful through publishing books that celebrate and preserve the heritage of America's people and places.

Find more books like this at
www.arcadiapublishing.com

Search for your hometown history, your old stomping grounds, and even your favorite sports team.

Consistent with our mission to preserve history on a local level, this book was printed in South Carolina on American-made paper and manufactured entirely in the United States. Products carrying the accredited Forest Stewardship Council (FSC) label are printed on 100 percent FSC-certified paper.

MADE IN THE USA